Wicked Albuquerque

Wicked Albuquerque

Cody Polston

Published by The History Press
Charleston, SC
www.historypress.net

Copyright © 2017 by Cody Polston
All rights reserved

First published 2017

Manufactured in the United States

ISBN 9781467137980

Library of Congress Control Number: 2017945025

Notice: The information in this book is true and complete to the best of our knowledge. It is offered without guarantee on the part of the author or The History Press. The author and The History Press disclaim all liability in connection with the use of this book.

All rights reserved. No part of this book may be reproduced or transmitted in any form whatsoever without prior written permission from the publisher except in the case of brief quotations embodied in critical articles and reviews.

CONTENTS

Preface 7

PART I. THE WICKED WILD WEST 9
The Sandia Mountain Desperado 10
No Justice for Marshal McGuire 14
The Four-Legged Bootlegger 18

PART II. WICKED OLD TOWN 21
The Old Town Ruffian 21
The Judge Who Fined the Dead 30
The Wayward Priest 37

PART III. WICKED NEW TOWN 44
The Lilly of Copper Avenue 45
The Murderous Sheriff 54
Hell's Half Acre 64
Balloons, Daredevils and Death 77

PART IV. THE WICKED ART OF WAR 85
The Battle of Albuquerque 85
The Price of Treason 93
Lost Cannons and Legends 101

Contents

PART V. ATOMIC WICKEDNESS	109
Doomsday in Albuquerque	109
Trinity and the Soviet Spy Ring	114
Bibliography	123
About the Author	127

PREFACE

Albuquerque is a magnificently unique combination of the timeworn and the highly contemporary—nature, the man-made environment, the frontier town and the cosmopolitan city. It is a spectacular mix of incredibly diverse cultures, cuisines, people, styles, stories, pursuits and panoramas. It is a city with a rich history, evidence for which includes inhabitation dating back as far as twenty-five thousand years. It is one of North America's oldest cities and has had its share of lawlessness, conspiracy and even a scandal or two. Surrounding these events were some of the shadiest characters in New Mexico's history.

One outlaw in Albuquerque was so shadowy and mysterious that many historians have never heard of him. That outlaw was known as Joe Chancellor. He was a trusted friend of Tom Ketchum and a mortal enemy and rival of another local outlaw named Dave Atkins. He was a known member of Butch Cassidy's Wild Bunch. He knew Butch Cassidy and the Sundance Kid personally, as he participated in many of their robberies. After the breakup of the Wild Bunch, Chancellor was completely forgotten or ignored for more famous outlaws.

Freedom of the press was hard to come by during New Mexico's early statehood. Tom Hughes, the editor of the *Albuquerque Daily Citizen*, served sixty days in the Bernalillo County Jail in Old Town in 1859 on a contempt of court charge for refusing to divulge the authorship of a front-page article attacking Judge Thomas Smith, a chief justice of the New Mexico Supreme Court. He continued to write daily columns for the newspaper from his

jail cell. Upon his release, the local citizens escorted him from the prison with a parade that was accompanied by a brass band. In 1919, Carl Magee, editor of the *Albuquerque Journal*, also had his trouble with a judge who did not like what he wrote. Several times the judge attempted to jail Magee for contempt, but the governor of New Mexico would promptly pardon him. Their conflict eventually led to a gunfight that killed an innocent bystander.

Some of Albuquerque's historical wickedness is still rather shocking, even by twenty-first-century standards. José Ruiz was convicted of murder when he shot a young boy during a drunken spree in Old Town. The outraged citizens of Albuquerque demanded that justice be served. After a rather odd trial, José was hanged in the back room of Pat Gleason's Gold Star Saloon.

My personal interest in Albuquerque's history began when I was a tour guide in Old Town. From that, I developed a love of storytelling and a fascination in how the city once was. I also discovered that many of the stories had been embellished over time and included elements that were not historically accurate. One such example is the tale of the hanging of Albuquerque's first marshal. The legends claim that the new device used for his execution, a counterweight system as opposed to dropping the criminal through a hatch in the gallows floor, beheaded the convicted man and sent his head flying into the crowd of spectators. While researching this story, I was not able to find any historical evidence that this particular event occurred. As such, I chose to rely heavily on the newspaper accounts of the time to be able to present the most accurate account of the tale possible.

I would like to thank Cindy Able Morris from the University of New Mexico's Center for Southwest Research and Glenn Fye from the Albuquerque Museum photo achieves for their assistance in finding some of the more obscure historical images that are featured in this book.

The tales I have recorded here are just a small sample of the more interesting and controversial characters who inhabited the Duke City from the days when it was simply a small frontier town to the beginning of the atomic age. I hope that you enjoy reading about them as much as I enjoyed researching them.

Part I

THE WICKED WILD WEST

Albuquerque's rich past compares with that of the infamous Dodge City or Tombstone. The railroad brought new consumer goods as well as undesirables, including gamblers and the first prostitutes. In the late 1800s, the city had about twenty saloons, various gambling houses and several brothels. The red-light district flourished. Train robberies and gunfights were common occurrences, and most of the town's citizens carried pistols. Vigilante groups lynched a large number of outlaws. During this same time, Albuquerque also had a multitude of opium dens. There were public campaigns—not to close them, but merely to move them off Central Avenue, which was called Railroad Avenue back then, to either Gold or Silver Streets.

The impact of the railroad brought changes to the general architecture of the city. One legend says that around this time, Billy the Kid traveled to Albuquerque because of a tale that he had heard. Supposedly, a local hardware store owner had made several claims about what he would do should Billy the Kid ever step into his hardware store. Upon his arrival in town, Billy strutted into the hardware store, grabbed a plow and walked out with it while the store owner hid under a wagon.

Here are some of the more scandalous tales from Albuquerque's wicked Wild West era.

The Sandia Mountain Desperado

In October 1880, Colonel Charles Potter, the stepson of Rhode Island governor Charles Van Zandt, came to New Mexico. He was a surveyor for the U.S. Geological Survey, and his mission was to study the mineral resources of the territory for the 1880 U.S. Census. After a short stay in Albuquerque, he traveled to the Sandia Mountains to take reports on the mining districts in the mountains east of the city. He was particularly interested in the San Pedro Mining District, where he had purchased several shares. The locals warned him that his route was dangerous, as there had been reports of bandits in the area. However, the colonel shrugged them off, saying that he could take care of himself.

Potter departed Albuquerque on horseback soon afterward. He made a brief visit to the Hell Canyon diggings before he turned east toward Tijeras Canyon. This was the last sighting of the colonel before he vanished completely.

Albuquerque sheriff Perfecto Armijo was notified and began a search for the missing man. Ferdinand S. Van Zandt, a relative of Potter's, came to town in December and began retracing Potter's steps. In Tijeras, he learned that Potter had last been seen heading north toward Golden, but he was unable to hear anything else after that.

The newspapers in New Mexico published notices that offered a reward for any information concerning Potter. The federal government was also interested in the case because Potter was one of its employees. As such, Potter's disappearance became a national news story.

The following month, Potter's gold watch turned up at Basye's Jewelry Store in Albuquerque. Sheriff Armijo learned that the man who had hocked the watch was Pantaleón Miera, a known member of the Marino Leyba Gang. The watch had been hocked only two weeks before the sheriff's arrival, but Miera had been lynched in Bernalillo just days earlier for stealing horses.

Then Armijo got a tip that Escolástico Perea, another member of the gang, was in Isleta and had been talking about Potter. So, Sheriff Armijo rode out and arrested Perea. The sheriff brought the outlaw to the jail in Old Albuquerque, where he was questioned. Perea made a full confession and told the sheriff how the crime was committed.

In Tijeras Canyon, Potter had become lost and stopped at the residence of an outlaw named California Joe to ask for directions. Joe noticed that the colonel was well dressed and figured that he probably had some money on him. After giving Potter some directions, he informed the rest of the gang,

who, knowing his route, ambushed him. During the robbery, Potter was killed. Afterward, the bandits piled logs on the colonel's body and burned it.

Perea then led the sheriff to a spot twelve miles north of Tijeras, where they found the remains of Potter's body. Perea was insistent that he did not have anything to do with the killing of Potter. However, he quickly named Miera, Marino Leyba, Miguel Barrera, Faustino Gutierrez and California Joe as the perpetrators of the crime.

Leyba, who was known as the "Sandia Mountain Desperado"; Barrera; and California Joe all lived in the East Mountains in San Antonito. Barrera and California Joe were soon found and apprehended. They were promptly taken to Albuquerque, where they were put in jail with Perea.

Unfortunately for the trio, a local secret vigilance committee had learned of their capture. These vigilance cells took upon themselves the duty of "anticipating justice," meaning that when the local judicial system proved too slow, inept or corrupt, the vigilantes dispensed punishment.

On the morning of February 4, the *Daily New Mexican* published a front-page story reporting the details of the triple lynching at Albuquerque. A Santa Fe citizen who witnessed it gave a full account for the newspaper. The gentleman had gone to Albuquerque on business and happened to be walking down the street when the vigilance committee was on its way to the jail. He and his friends were grabbed by several of the men and detained securely until the lynching was over. The vigilantes comprised about two hundred people, all of whom wore masks to conceal their identities. The majority of them were Hispanic, with a sprinkling of Anglos. The vigilantes showed calm determination. Everything was conducted quietly and professionally with a no-nonsense approach. The jail guards did not resist, either because they were vastly outnumbered or perhaps because they approved of what was happening.

With no mercy, the vigilantes lynched the three members of the gang. After the hanging was over, the executioners expressed their regrets to the Santa Fe gentleman and his friends, and they were released.

On February 24, several deputies found Faustino Gutierrez hiding out near the town of Chilili. He was arrested and jailed. The next morning, he was found outside the prison, lynched. A note was pinned on his body that read, "Hanged by the 601, Assassin of Col. Potter." The meaning of "the 601" has remained a mystery that has never been solved.

Out of six alleged murderers, only one remained: Marino Leyba, the leader of the gang. Sheriff Armijo soon had another lead, placing the outlaw in eastern New Mexico in the town of Puerto de Luna.

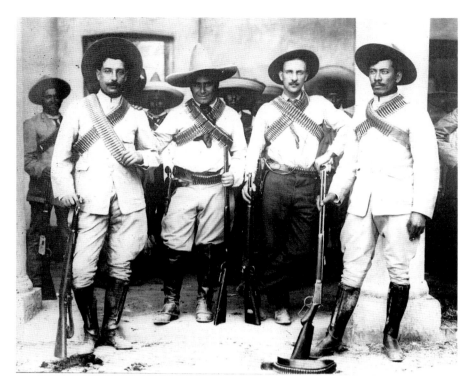

"Mercenaries" in Old Town. *Albuquerque Museum, Creative Commons (PA1977.65.61).*

Just two months earlier, Lincoln County sheriff Pat Garrett was in Puerto de Luna and had a run-in with Leyba. The outlaw walked up to Garrett and began boasting that he would like to see if that "damned gringo" could arrest him. Garrett, unaware of the warrants against Leyba, replied, "I told him to go away and not annoy me."

Leyba turned and stomped out onto the porch, where he continued swearing and berating the lawman. Not willing to take the bandit's verbal abuse, Garrett followed him out onto the porch. When Leyba raised his left arm in a "threatening manner," Garrett reportedly slapped him off the porch. Leyba landed on his feet and drew his pistol. He fired wildly and missed Garrett, the bullet striking a post on the porch. The lawman drew his gun and returned fire. His first shot went off prematurely, the ball hitting at Leyba's feet. However, the second shot hit the outlaw in his shoulder. Marino turned and ran, firing back at Garrett as he fled. For Leyba, the incident only earned him another charge on his arrest warrant.

The Wicked Wild West

By March 15, 1881, one of Sheriff Armijo's deputies had captured Leyba in Puerto de Luna and taken him to the San Miguel County Jail. The capture was big news in New Mexico and was reported by the *Las Vegas Gazette* on March 20:

> *Sheriff Perfecto Armijo of Bernalillo County, accompanied by his brother, Mariano Armijo and Russell Wright, attorney at law, came up yesterday to take the prisoner, Marino Leyba to Albuquerque, on a warrant for assault with intent to kill. Leyba has been indicted for this crime in the district court in Bernalillo County but is not yet indicted for the murder of Col. Potter although he was the leader in that offense. He is likewise charged here for an assault with intent to kill. As these two indictments are crimes of equal magnitude and Leyba pleaded strongly to the court to be detained in jail at this place, Judge Prince ordered him to be kept here until indicted for the high crime at Albuquerque where he will have to be taken for trial. Sheriff Armijo and brother and Mr. Wright remained in town yesterday and will return home today.*

Although Sheriff Armijo wanted Leyba to stand trial for the murder of Colonel Potter, the grand jury could not indict him because there were no witnesses—they had all been lynched. Instead, Leyba was tried for the attempted murder of Garrett. On August 19, 1881, he was found guilty and fined eighty dollars. He was also convicted of horse theft and sentenced to seven years in prison.

The story of the Sandia Mountain Desperado ends in controversy. Leyba was released early in 1886 after being secretly pardoned by the governor of New Mexico. He was soon wanted again for the brutal murder of two sheepherders near Estancia. The *Santa Fe New Mexican* describes what happened next:

> *Marino Leyba, the notorious Bandit, pardoned by Governor Ross, was shot and killed in the Sandias and his body was brought into Santa Fe today. He was drunk when he resisted the deputy sheriff's who killed him.*
>
> *The New Mexican is not ready to believe that the governor was induced by a money consideration to pardon this man Marino Leyba out of the penitentiary last July, as darkly hinted by some of our exchanges, but the people generally would be better satisfied if there were a little more publicity of the pardons and if the old gentleman would explain his reasons for turning loose on them this desperado. While the governor*

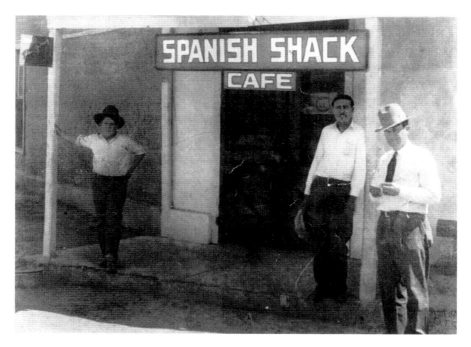

Sheriff Perfecto Armijo (*right*) in front of Maria Aragon's Old Town chili parlor.
Emma Moya Collection, Center for Southwest Research, University Libraries, University of New Mexico.

is at it, there are number of other pardons to explain. Why not publish the name of the convict pardons every time there is a pardon? Why all this secrecy?

The questions posed by the newspaper would never be answered.

No Justice for Marshal McGuire

On Saturday, November 20, 1886, Marshal Michael Robert "Bob" McGuire learned that two cowboys, who had been accused of stealing horses, had been spotted at the northern edge of Albuquerque. The pair was supposedly loitering around Pasqual Cutinola's dance hall in Martineztown. Having warrants for their arrest, he called for his deputy, E.D. Henry, and the two officers rode out to apprehend the outlaws. The wanted men were Charlie

Ross and John "Kid" Johnson. Both men were dangerous career criminals and rumored to be wicked with six-shooters.

The two officers arrived at the dance hall at about 9:00 p.m. and began to search the building. After talking to several witnesses, they quickly determined that the two young desperados had just left the saloon with two young women. Believing that the foursome could still be nearby, McGuire and Henry began searching the neighborhood.

They were only twenty feet south of the dance hall when McGuire looked in a window of an adobe house. Inside he saw two cowboys who fit the description of the suspects. Quietly, the officers walked to the window to get a better look. Gazing inside, they saw the two outlaws seated at a table eating with two young women, Simona Moya and Terecita Trujillo. The two officers moved to the closed front door, where they devised a simple plan to capture both men safely. At the marshal's signal, they would burst through the door and rush the two bandits with their guns drawn. McGuire would go after Johnson, while Henry would rush Ross. They hoped that the move would take the men by surprise, enabling them to make the arrest without any gunfire.

Inside the house, the group had just finished their meal. Miss Trujillo was clearing off the table when Kid Johnson asked for a glass of water. Miss Moya picked up a water pitcher and started to go outside to the well. As she opened the door, the two police officers came bursting through it. All three were caught by surprise. The collision between McGuire, Henry and Miss Moya resulted in the trio falling to the floor. The outlaws grabbed their guns and started firing.

McGuire quickly jumped back up and rushed toward Johnson, who was now on the other side of the room sitting on a trunk, attempting to disarm him. A stray bullet hit the light, and the two girls screamed and dove for cover under the bed. Precious seconds passed as Henry, whose progress was blocked by the half-open door, rushed at Ross, who was sitting on a bed on the other side of the room. The delay in his entry gave Ross time to aim his gun and squeeze off two shots. The first bullet hit Henry in his right leg. The second hit him square in the chest. The deputy fired back at Ross as he fell to the floor.

While McGuire fired at Johnson, who was shooting wildly in all directions., the marshal came under fire from Ross. In the darkened chaos, gunfire continued for several more seconds. When a lamp was finally lit and the gun smoke had cleared, Henry lay dead on the floor. Marshal McGuire was also down but still alive. The outlaws had escaped, fleeing in opposite directions.

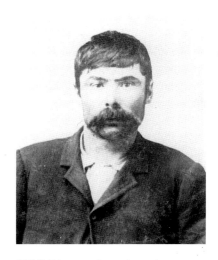

"Kid" Johnson, the outlaw who got away. *Library of Congress.*

McGuire received two bullets in his abdomen and one in his arm. Kid Johnson escaped practically unharmed and made fast tracks for parts unknown. Ross was wounded as well. One bullet had struck his shoulder and lodged against his shoulder blade, while a second had grazed his head. He stole a horse that was hitched to a fence and began riding west on Mountain Road toward Old Town. Weakened from the loss of blood, he soon fell from the horse. Knowing that he would not make it, he changed directions and managed to walk to a friend's house in the red-light district of Albuquerque.

The next day, at 11:00 a.m., Ross was found and arrested by Officer Pete Isherwood and Carl F. Holton, a Santa Fe Railway detective who had previously served on the Albuquerque police force. They placed Ross under arrest for the murder of Henry and the wounding of McGuire. The arrest was made without incident, and Ross was taken to the county jail in Old Town.

Marshal McGuire lived for almost a week, finally dying from his wounds on November 26, 1886. The flags in Albuquerque were flown at half-staff, and mourning crepe was placed outside the business houses. The popular law officer, who died at the age of forty, was taken back to his native Oswego, New York, for burial by his brother. Deputy Henry, a native of Ohio, was buried at Fairview Cemetery in Albuquerque. The effects of the murders were very profound, as these two men composed the entirety of the Albuquerque police force in 1886.

Meanwhile, in the Old Town jail, Charlie Ross claimed that McGuire and Henry shot first and that he did not fire his pistol until he had already been shot. He also claimed that he had no idea why the officers were after him and that he fired his gun in self-defense.

He remained in the county jail until the night of January 3, 1887. Ross had teamed up with another inmate named Peter Trinkhaus, who had been convicted of murder and sentenced to life imprisonment. The pair had obtained a key to their cell—or perhaps the jailer was bribed to unlock

the cell door. They escaped through an unbarred window after opening their cell.

The next morning, a note was found on the windowsill written by Charlie Ross and addressed to the editor of the *Albuquerque Daily Democrat*:

> *County Hotel, Jan. 3, 1887. To Mr. Roberts, of the Democrat:*
>
> *Please say in your paper that hearing there is a reward offered for my partner, Johnson, that I have gone to find him. Tell the boys not feel uneasy about my absence, and as the weather is such that they might take cold, it may be better for their health to stay at home, We'll turn up in time, and don't you forget it.*
>
> */S/C. Henry Ross, with his hair parted in the middle.*

Ross and Trinkhaus were eventually recaptured three weeks later after they were arrested for derailing and robbing a train. Ross was returned to Albuquerque but escaped again in July after being in confinement for only six months. Ross was later released from the train wrecking charge.

Charlie Ross and "Kid" Johnson were never prosecuted for the killings of either McGuire or Henry. After investigating the facts of the shooting, the grand jury determined that the shooting was in self-defense. Additionally, it ruled that Marshal McGuire had not obtained a proper warrant and that the officers were disguised in such a way that Johnson and Ross could not have known that they were police officers.

As a result of the gunfight, the Albuquerque City Council gave policemen some "latitude" in the use of firearms in making arrests. They previously had orders never to use their arms except in the case of being fired upon. The new change stated that any criminal might be shot by the police if he made a show of his arms or attempted to use them.

On the 125th anniversary of the marshal's death, Paul Judd, the curator of the Albuquerque Police Museum, researched and discovered that Marshal McGuire was never given a proper burial. He contacted the cemetery where McGuire was buried, with no headstone, and the caretakers of the cemetery located the fallen marshal's body. The cemetery donated a proper headstone, and a funeral was held, complete with an honor guard and attended by hundreds, including New Mexico governor Susana Martinez.

The Four-Legged Bootlegger

This is the true story of a horse that was arrested and tried for a felony in a federal court in New Mexico.

Fred Lambert was serving as a deputy special officer for the U.S. Indian Service. The service was an agency set up to carry out treaty obligations and run the reservation system within U.S. policy. One of these policies involved enforcing a law that prohibited the use and sale of alcohol on Indian reservations.

In November 1913, Lambert was patrolling the Jemez Pueblo during its annual festival when he spotted something very suspicious. A large Hispanic man was riding into the pueblo. Hanging off his horse's saddle were thirteen gunnysacks. As the horse trotted along, he was able to make out the sound of glass bottles clinking together inside the sacks. Suspecting that the man might be bootlegging alcohol onto the reservation, Lambert grabbed the suspect by his coat and yanked him out of the saddle. As the horse started to startle, Lambert grabbed the reins. As he settled the horse down, the Hispanic man got back up and began to flee. Another deputy, who had noticed all the commotion, quickly set off in pursuit of the suspect. However, before he could apprehend him, the Hispanic man jumped into the river, hoping to make a quick escape. The deputy fired four or five shots at the man before he disappeared into the willows that lined the riverbank. A quick search of the area confirmed that the suspect had gotten away.

Meanwhile, Lambert discovered that he had been correct. Each of the gunnysacks contained a quart bottle of alcohol. In the hope of getting a lead on the escaped felon, he arrested the horse for transporting alcohol on an Indian reservation and took the animal back to the marshal's office. An ad was then placed in the newspaper that provided a description of the horse and noted that it had been found on the Jemez Pueblo. It concluded with the statement that

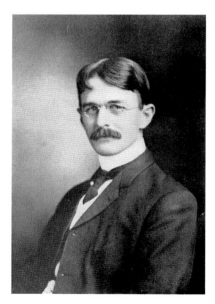

Judge William Pope. *Photograph from Representative New Mexicans, vol. 1 (1912).*

Fred Lambert. *Albuquerque Museum, Creative Commons (PA2006.21.624)*.

anyone wishing to claim the lost horse could do so at the U.S. Marshal's Office in Santa Fe.

For six months, the horse remained in the marshal's custody. Apparently, no one was foolhardy enough to approach the authorities to claim the missing animal. However, the cost of housing and feeding the horse was growing. The issue of the four-legged bootlegger needed to be resolved. So, in May 1914, the animal was put on trial for illegally transporting alcohol on an Indian reservation. Although the horse itself was not in the courtroom, an attorney was appointed by the court to represent the horse.

The first federal judge for the State of New Mexico, William H. Pope, presided over the hearing. What was ironic about Judge Pope hearing the

case is that one of his decisions on the federal bench had been reversed by the U.S. Supreme Court just one year earlier. The issue was whether an 1897 federal law that criminalized the sale of alcohol to Indians applied to the Pueblos in the state of New Mexico. Pope had ruled that the Pueblos were ordinary citizens living on private property and did not fit into the classes of Indians defined in the 1897 law. The Supreme Court reversed his decision, saying that the Pueblos were a dependent people, which Congress had made clear in the Enabling Act. The Enabling Act provided that, as a condition of statehood, New Mexico must agree to prohibit the introduction of liquor into Indian country, "which term shall also include all lands now owned or occupied by the Pueblo Indians."

Considering the reversal, the judge probably thought that the idea of putting a horse on trial for bootlegging alcohol was probably "something different," and he seemed to have a good sense of humor about the whole affair.

After the prosecution and defense presented their sides and all the evidence was put forth, the jury retired. After having lunch and visiting the defendant in a corral nearby, they returned the verdict of not guilty. It was their judgment that the horse had been coerced into taking the alcohol onto the reservation. Since the horse had run up a feed bill of $24.32, they also ruled that the horse was to be sold at a public auction to pay for the incurred costs. The horse was eventually sold at auction to a northern New Mexico rancher, who bought it for his daughter.

Part II

WICKED OLD TOWN

A view of what Old Town Albuquerque was like in the late 1800s can be found in the memoirs of Mrs. Heacock, the wife of one of the city's infamous judges. Before the coming of the railroad, there was nothing very practical in the way of law or law enforcement. There was lots of stealing, especially horse thieving, as well as the occasional shooting. People had to take the law into their own hands, and more often than not, thieves were hanged on the tree nearest to the place where they were caught.

In the 1880s, Albuquerque's sheriffs were chosen in quite an unusual manner. Perfecto Armijo and Santiago Baca took turns between them serving as a peace officer. When it was time to "elect" a sheriff, they would collect their toughest friends, meet in a vacant lot and do battle with sticks, rocks, gun butts and fists. Judge William Heacock was the referee of the public display; a crowd would gather to watch and vote for the winner.

Many of these pioneer men and women forged their place in the history of the city through their inconceivable deeds. Here are the stories of a few of them.

THE OLD TOWN RUFFIAN

Elfego Baca stood on both sides of the law. During his lifetime, he single-handedly took on eighty Texas cowboys in a shootout, planned at least two

jailbreaks and served as an attorney for General Huerta during the Mexican Revolution in 1914.

Elfego Baca was born on February 27, 1865, in Socorro, New Mexico. Just after his first birthday, Elfego's family decided to relocate to Topeka, Kansas. When their wagon was forty miles southeast of Albuquerque, they were attacked by a renegade group of Indians. During the ensuing conflict, baby Elfego was kidnapped. Despite all odds, the infant was eventually returned to his parents four days later, none the worse for wear.

Elfego and his family stayed in Topeka for seven years until his mother died in 1872. His father then returned him to Socorro to live with a relative and learn the trade of being a *caballero*, or cowboy. His father returned to New Mexico a year later and settled in Belen. There he became the town sheriff. At the time, Belen was still a turbulent Old West town that sprang up because of the construction of the railroad. The elder Baca was considered to be a competent law enforcement officer until he got into trouble after shooting two rowdy cowboys for "disorderly conduct." He was arrested and locked up in the old adobe jail in Los Lunas. The word that his father had been imprisoned reached Elfego shortly afterward. Now a teenager, he and a friend walked fifty-five miles to Los Lunas to break his father out of jail.

The Los Lunas jail was a two-story adobe building that contained a courtroom and several offices on the top floor. The jail cells were located underneath and were highly fortified. As Elfego hid in the bushes and watched the routine of the guards, he devised a plan. The feast of St. Theresa was going to be held later that evening, which would offer some distractions that Elfego could use to his advantage. Once night fell, he waited for the jailer to abandon his post to join in the eating and drinking. With his friend being a lookout, he made his way to the rear of the courthouse, where he had spotted a cleaning ladder. Using it, he made his way to the second floor and broke in through a window. Once he was inside, he sawed a hole in the wooden floor to let his father out. After the pair had escaped out of the building, Elfego returned the ladder to the place where he had found it. After stealing some dried venison and chile in the back of the jail, the trio hid seventy-five feet away in a clump of high grass.

The next day, they observed the movements of the posses, remembering which direction they rode off. Using that information, Elfego was able to determine the safest route of escape. After sunset, the group left Los Lunas and obtained some horses from a friend in Albuquerque. Elfego and his friend returned to Socorro, while his father rode to a village near El Paso, where he would stay for the next seven years.

Wicked Old Town

In 1881, Elfego Baca met Billy the Kid at a round-up at the Ojo de Parida ranch. The pair quickly became friends and decided to travel up north to have a little fun. Their destination was Albuquerque, which at the time had more than forty saloons in the Old and New Town areas. They rode up to Isleta, where they left their horse and hitched a ride on a railroad foreman's cart. What happened next was related to Kyle Crichton by Baca during an interview:

> *Billy and I went to Old Town which was wide open, liquor of all kinds, women of all kinds. Billy carried a little pistol called a Bulldog repeater; when it fired it made a noise perhaps louder than a .45 gun. We went into a bar called the Martinez saloon where there was gambling, drinking, and every other thing. Billy and I went out. Billy thought the town was more silent than what he expected. He fired a shot up in the air, and it made an awful strong noise. Here comes the deputy sheriff, a very brave man by the name of Cornelio Murphy. He searched both of us and was very mad. Billy made most of the talking to him in Spanish. The deputy charged us of having fired that shot, but he couldn't find a pistol. The deputy walked away, so did we. The deputy must have been about one block away when Billy fired two more shots. The deputy came back about as mad as a man could be and searched us again, he called us every name that he could think of. Anyhow, we went back to the Martinez saloon. While in the saloon Billy fired once more and the lights went out. Billy and I determined to leave the place, and we did. Every time Billy fired a shot he put the pistol under his hat, and it was a stiff, derby hat.*

At the age of nineteen, Baca was working in Socorro for José Baca when the sheriff of Frisco, Pedro Saracino, came riding into town in the hopes of finding some assistance with a group of cowboys that was terrorizing his village. He told several stories of the brutality of the "Slaughter Gang." Comprising about 150 cowboys, the group's actions were putting the citizens at risk. Baca became so angry with hearing the tales of depravity that he volunteered his assistance and became an unofficial deputy sheriff.

The following day, he left for Frisco. Shortly after arriving, he located one of the gang's cowboys. Baca immediately tried to arrest the man, but the cowboy managed to escape. Undaunted, he tracked the cowboy to a nearby ranch and, in the presence of thirty other cowboys, made the arrest. The young "unofficial" deputy sheriff took his prisoner back to Frisco to the home of Sheriff Saracino. However, the sheriff of Frisco was still in

Socorro. Before Baca could figure out what to do next, a party of at least two dozen cowboys rode into Frisco and demanded that he release his prisoner. Baca responded by giving the cowboys a three count before he would open fire. When the gang of cowboys ignored his warning, Baca shot in the hopes of scaring them off, but in the process, he killed one of the cowboys' horses. The horse fell over on its rider, indirectly killing the man.

The following day, more cowboys arrived. This time, they told the young deputy that they would personally take the prisoner to the jail in Frisco. Baca saw through the ruse and refused the offer. The cowboys responded by threatening him. If their man were not released, the entire gang would come down upon him. He had killed one of their men, and now they wanted justice. Again, Baca refused to release his prisoner. The cowboys rode off with intimidating promises that they would return soon.

Baca's first concern was for the townsfolk. He urged them to take refuge inside the church. Just as this was completed, the cowboys returned in force. Eighty Slaughter hands dismounted and nonchalantly walked up to Baca. Before they knew what had happened, he had grabbed the guns from two of the cowboys' holsters and run into a *jacal* close by. The occupants of the house fled as the cowboys closed in on his position.

The ensuing gun battle lasted for thirty-six hours. The cowboys fired four hundred bullets into the *jacal* in an attempt to kill the young deputy. Baca was saved because the floor of the *jacal* was below ground level, giving him an ideal place to take cover from the cowboys' gunfire. He tricked the cowboys by putting his hat on top of a statue of a saint. He then put the statute in a window, giving the cowboys a target to shoot at. His hat was covered with bullet holes, but the statue of the saint was miraculously undamaged.

The cowboys tried everything they could think of to flush Baca out. They even tried dynamiting a portion of the *jacal*, but nothing would force Baca to quit. On the second day of the gunfight, another deputy marshal arrived, and after talking to Baca, he negotiated a deal with the cowboys. Baca was allowed to keep his guns. Six of the cowboys would lead the way while the deputy sheriff would ride with Baca in a wagon at the rear. When they arrived in Socorro, Baca was charged with the murder and held in the Socorro jail for four months before being transported to Albuquerque for the trial.

While in Albuquerque, Baca met Francisquita Pohmer. She was the sixteen-year-old daughter of a German immigrant who owned the Old Town Meat Market. Baca soon fell in love with her and proposed. Francisquita promised to marry him, but only if he was acquitted of the

Wicked Old Town

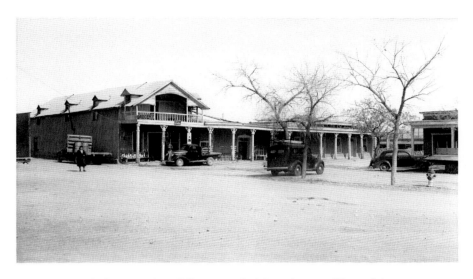

The Baca store in Socorro where Elfego was asked for assistance. *Library of Congress.*

murder charges. After he had been exonerated of the crimes, the two were married in the San Felipe de Neri Catholic Church on August 13, 1885.

The couple moved into a house in Old Town. Baca was employed at the jail in Old Town, serving as the county jailer. However, after getting into several mishaps around the city, a local newspaper printed a story in which it called him "the Old Town ruffian." One such mishap occurred in 1886 during an argument with Mrs. Josefa Werner in which he was accused of displaying a weapon in a threatening manner.

On another night, Baca and his friend Jesus Romero were sitting in a saloon having a drink when a police officer, Henry, entered the bar and placed Romero under arrest. Romero resisted, and when the lawman got a little too rough, Baca rushed to the aid of his friend. Using his gold pocket watch, Baca struck the arresting officer on the head, knocking him out cold. Romero fled, but several other men grabbed and subdued Baca. He was taken immediately to the judge, who sentenced him to spend thirty days in jail or pay a penalty of $17.19, including costs. Baca refused to pay the fine and chose the jail time. What the court neglected to remember was that Baca himself was the jailer. After signing "the prisoner" in, Baca went about his own business and collected the $0.75 per day allotted for feeding the inmate. By the time he had "finished" his sentence, Baca had made $22.50. Soon afterward, Baca moved back to Socorro to pursue a career as a lawyer.

In 1893, he was elected Socorro County clerk, a post he held until 1896. A year later, while still acting as clerk, he was admitted to the practice of law. He would go on to hold many public offices: mayor of Socorro from 1896 to '98, school superintendent of Socorro County from 1900 to 1901 and district attorney for Socorro and Sierra Counties from 1905 to 1906.

By 1906, Baca had left public office and become a bounty hunter. He was hot on the trail of a Kansas cattle thief named Gillette, who had fled to Mexico to avoid being captured. With a $5,000 price on his head, the thief had no other option. In Parral, Baca met with the Mexican revolutionary Pancho Villa and made him an offer. He would pay Villa $1,000 if he would kidnap Gillette and bring him to the U.S. border. There Baca would be waiting to capture Gillette and claim the reward. However, the deal went sour when the reward for the horse thief was withdrawn.

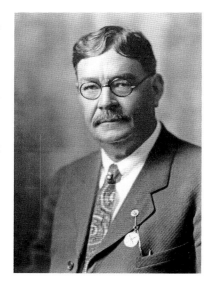

Elfego Baca while he served as district attorney for Socorro and Sierra Counties. *Albuquerque Museum, Creative Commons (PA1978.153.869).*

During the Mexican Revolution in 1914, the two met again. This time, Villa asked Baca to secretly meet him in Juarez to smuggle some stolen merchandise into the United States. Baca agreed to the deal. Unfortunately, Baca underestimated the increase in border security caused by the revolution and was detained by border guards. By the time he reached the appointed rendezvous site, Villa had already left. Pancho accused Baca of misappropriating his property and said that he would kill him if he ever stepped foot in Mexico again. Baca, who was not intimidated by the bandit's threat, retaliated by stealing Villa's prized Mauser rifle. Infuriated, Pancho placed a $30,000 price on Baca's head. Allegedly, Baca tried to collect the reward himself by setting up a fake capture. However, the plan never came to fruition.

Baca returned to his law office and to Albuquerque to continue his business. Soon he had another job, this time representing General Victoriano Huerta's counterrevolutionary army in Mexico. While serving as legal counsel for the general, Baca received a request to represent General José Salazar, one of

Huerta's top officers. Salazar had been convicted of several charges and was being held at Fort Bliss. Salazar had been found guilty of robbery in El Paso, where he was apprehended by the U.S. Army. Baca agreed to represent Salazar and defended him, but when Salazar was convicted of perjury, the general was sent to Albuquerque for another trial.

After arriving in New Mexico, Salazar's staff implemented a complicated plan. A mysterious woman called Señora Margarita scouted the jail by pretending to be a good Samaritan bringing the prisoners food. This allowed her to view the interior of the prison to create a map of the building and pinpoint the general's location. She also scouted the town from the jail to the railroad depot. The general's staff officers arrived shortly after that, disguised as beet pickers. After receiving the map and other information from Señora Margarita, the "beet pickers" took up their positions.

At 9:30 p.m., Señora Margarita frantically called the jail telling the jailer that her house was being broken into. The jailer ran to the rescue, leaving a man named Charley Armijo in charge. Armijo was quickly overpowered by the "beet pickers." The general was then released, and the party fled to a car waiting outside. From the jail, Salazar was taken straight to the train depot, where he boarded a train bound for El Paso.

Meanwhile, Elfego Baca was in the Graham Saloon drinking with friends. Although this presented an ironclad alibi, he was tried for complicity in the jailbreak. Witnesses later claimed that Salazar leaned out of the window of his car as he passed the saloon and shouted, *"Adios y gracias mi amigo Elfego!"*

Baca was arrested on two counts of conspiracy. The *El Paso Herald* reported the outcome of the trial:

> *One of the two counts of the indictment for conspiracy against Elfego Baca was dropped today by the United States Attorney Summers Burkhart in the federal court, upon motion of attorney A.B. Renehan to dismiss the case. The count dropped is the One charging conspiracy to take Gen. Salazar with violence from the custody of the United States Marshal.*
>
> *The remaining count charges conspiracy to assist Salazar to escape. Judge Pollock at the same time ruled that the question of conspiracy is for the jury and that it is better for the jury to pass upon it then for the court.*
>
> *Jailer Carlos Armijo, on the stand, told the story of Salazar's escape on the night of November 20, 1914. Mrs. Celestino Otero of El Paso, in response to the question of the defense which reflected upon her, shouted: "it is none of your business."*

The man who stood up to Pancho Villa. *William A. Keleher Collection (PICT 000-742-0006), Center for Southwest Research, University Libraries, University of New Mexico.*

WICKED OLD TOWN

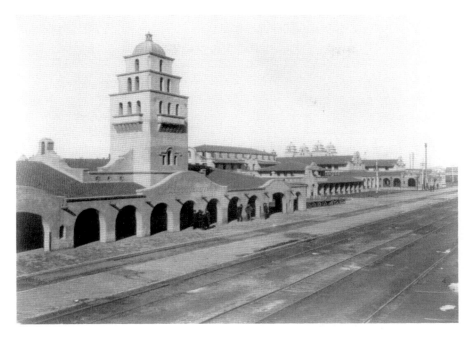

The Alvarado train station, where General José Salazar made his escape. *Library of Congress.*

> *She returned to the stand to correct her statement that she and her husband had met Elfego Baca on November 20th, correcting it by saying it was the 19th, and that Baca said to her husband, "remember that you, Vigil and Trinidad are to be at the jail tonight."*
>
> *When pressed to explain why Baca should have said "be at the jail this evening" when the Escape did not take place until the following night, she said she was mistaken and changed the reputed converse to "be sure and be at the jail tomorrow night."*

In the end, Baca was never charged, although the authorities have always thought that he was the mastermind behind the escape because he stood to profit if General Huerta had acquired any more power. Baca returned to Socorro in 1919 and was elected sheriff. He held the position for just over a year.

For the majority of his life, Baca lived in Albuquerque. He became a legend that was often on both sides of the law. He was also a man of very few words. The *Albuquerque Evening Herald* once called him "the New

Mexico Sphinx" as the "Sphinx of Egypt has not spoken a word in at least 7,000 years."

The extraordinary career of Elfego Baca ended with his death on August 27, 1945. He was eighty years old.

The Judge Who Fined the Dead

William Crawford Heacock gained an appointment to the United States Naval Academy at Annapolis, Maryland, where he enrolled on September 22, 1868. He graduated from the Academy on June 1, 1872, and began his career as a naval officer serving aboard the USS *Lancaster*. He excelled as a midshipman and was eventually promoted to the rank of ensign.

During his tour of duty, he met and fell in love with Annie Ellen Coxe while visiting the city of Nice, France. Mrs. Coxe was the wealthy divorced daughter of William Morris Griscom, who was the owner of Reading Hardware Company. This made him one of the richest men in the United States. After a brief courtship, the couple was married on December 1, 1875. Mr. Griscom gave the couple a $50,000 residence along with a sizeable sum of money as a wedding present.

At the insistence of his new bride, William C. Heacock resigned his commission with the navy twenty days later. He returned to his home in Reading, Pennsylvania, where he continued his study of law. Within a few years, he was able to open his practice. However, a life of extravagance slowly dissipated the couple's fortune. William tried to reenlist in the U.S. Navy at his former rank of ensign, but the navy wouldn't allow it.

Fortunately, word had spread that the New Mexico territory was in need of lawyers. So, in 1881, he moved his wife, son and two daughters to the city of Albuquerque to seek employment. His domestic life was soon in ruins when his wife, who missed the refinements of the East, packed up her belongings and returned to Reading with the children. She filed for divorce in 1883.

Heacock remained in Albuquerque and began making influential friends within the Democratic Party. He eventually became the editor of the *Albuquerque Journal* and the first police judge in Old Town. He became the law in Albuquerque.

In December 1890, he married Mrs. Mary Satterfield, and the couple had three daughters and a son. Before her death in 1956, Mary gave an interview

concerning the life of the judge. Thanks to that interview, these amazing stories have been passed down. One of the most notorious and humorous concerns the judge fining a dead man—somewhat embellished with time, perhaps, but a good story nonetheless, and it is based on fact. It occurred in the late 1800s in the old courthouse in Old Town:

Judge William C. Heacock and his cronies were playing three card monte in the back room of a saloon. The cards were against the judge that evening, and along about one in the morning, he found himself without funds to continue his game. As was customary with the judge in such critical situations, he called in his deputies who were drinking at the bar in the next room.

"Get me a drunk," he ordered, "a drunk with money in his pockets that is guilty of disorderly conduct."

The deputies departed on their familiar mission, and the judge retired to the courtroom on the upper floor, where he prepared to hold a session of night court. A town like Albuquerque needed a night court to keep it in order.

Before long, the deputies returned, carrying a limp man between them.

"What the hell?" said the Judge. "What's that you got?"

"Your Honor," replied one of the deputies, as he straightened up from placing his burden on the floor, "we found him in the back room of the Blue Indigo."

"Can he stand trial, or is he dead drunk?" asked the judge.

"He's not drunk, but he's dead all right. He croaked himself over there in the Blue Indigo. The proprietor insisted that we get him out of there."

The judge was annoyed. "Didn't the fools ever hear of an inquest?" he asked. He had sent for a lucrative drunk, not a drooling suicide.

He turned solemnly to his deputies. "This court is a court of justice," he said. "The right of habeas corpus must not be ignored. The prisoner must be given a speedy and fair trial. This court is ready to hear evidence. What is the charge?"

"Your Honor," spoke one of the deputies, "the charge has not yet been determined."

"This court will hear no case without a charge. Did you search the prisoner?"

"There was a letter to some dame——" began the deputy.

"Any money?"

The deputy counted $27.32.

"Any weapons?"

They removed a gun from the man's hip pocket.

"Does the prisoner have anything to say before I impose the sentence upon him?"

Judge Heacock leaned forward and cocked his ear towards the prone prisoner. "Because of the unresponsiveness of the prisoner, which this court interpret as contempt, and given the unlawful possession of a lethal weapon this court imposes a fine of $20.00 plus court costs," pronounced the judge.

"You might as well leave him there till morning," said the judge as he pocketed the money. The Monte game continued on the floor below.

Mrs. Heacock said they used to do funny things in Albuquerque in those days, and many of them were done in the name of justice. She remembered the time when a well-dressed stranger arrived on the train from the East. He took a hack to the hotel on First Street and was just paying the hack driver when two prominent deputies apprehended him and took him before the judge for being a suspicious-looking character. "Because he was too well dressed and the city needed money that day," she added.

There is also the story of how Judge Heacock sent Elfego Baca to his own jail for a month. Mrs. Heacock laughed about that one too. The story is told in Kyle Crichton's book *Law and Order Ltd*:

Judge Heacock's deputies were out searching for anyone breaking the law, possibly a drunk, for the night court. When they attempted to arrest Jesus Romero, who was a friend of Elfego Baca's, Mr. Baca objected to the extent of hitting one of the policemen over the head with his oversized gold watch. The injured officer was one of Albuquerque's favorite police officers. When the crowd saw him lying unconscious, they quickly assisted the other deputy in apprehending Mr. Baca and escorted him to the night court. Meanwhile, Romero was forgotten and fled.

Mr. Baca was charged with "Disorderly conduct" which he adamantly denied. While booking him, the night sergeant discovered $18.19 in his pocket. This caught the interest of the Judge who quickly pronounced his sentence.

"Thirty days or ten dollars plus costs," the Judge exclaimed.

But they couldn't pull that stuff on Mr. Baca. He took the thirty days, and a deputy accompanied him to the jail in Old Town. Baca would soon have the last laugh because unknown to the Judge; he had recently been hired as the new jailer. The name of E. Baca was signed in the jail's record book, and the jailer, Mr. Elfego Baca, received the regular seventy-five cents

WICKED OLD TOWN

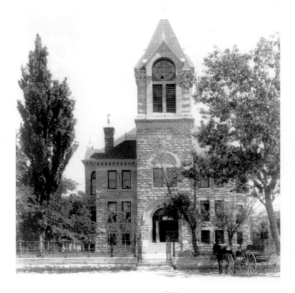

The old courthouse in Old Town where the "night court" was conducted. *Library of Congress.*

a day for the feeding of the prisoner. At the end of the month, Mr. Baca was $22.50 the richer for his encounter with the Albuquerque night court.

Another interesting story about Judge Heacock concerns a trip that he took with his wife and children to Jemez—it had all the elements of a good western story: covered wagons, Indians, quicksand and a wall of water. It was told by Mrs. Heacock after the judge's death.

She and Judge Heacock started out with their two babies for Jemez Springs, a three-day trip by wagon. They traveled in a big covered wagon, called an ambulance, from the Spanish *ambulanza*. They had six horses, two to pull the wagon and four extra in case of trouble. They took what furniture they would need in Jemez, two boys to drive and care for the horses and a girl to look after the babies, although Mrs. Heacock said she hardly ever did because she was too busy talking to the boys:

"I never wanted to go in the first place," Mrs. Heacock said, "but the Judge wouldn't have it that way. We had to sleep on the ground, right on the ground with my two babies I was so particular about. We would coil the big ropes used for the horses around us to protect us from the snakes, but

The Old Town Plaza in 1940. *Library of Congress.*

I was always scared to death, though I was so tired at night I couldn't help sleeping some. The coyotes would howl, and my it was a fright, but that man of mine would go in spite of anything."

The second day out they got lost on a mountain. The men went to look for someone who could help them to find the right road again. "I didn't like that at all," Mrs. Heacock said, "being left there alone with only that helpless girl and my two babies, and heaven knew what wild animals and Indians were about."

Suddenly they heard a whoop, and an Indian came riding over the hill.

"I grabbed the gun," Mrs. Heacock said, "though goodness knows I didn't know how to shoot one. And there were my two babies lying in the bottom of the wagon, and that Indian riding right for us for all he was worth. I decided to wait till he got almost to us before I tried to shoot. Then he yelled, 'Pretty soon, pretty soon, now,' and I put the gun down. He meant they were going to get us out of there pretty soon."

That night they spent in an Indian settlement called "Zia." They had a whole one room house to themselves with a big bed for Mrs. Heacock

and the girl and the babies. She thought that was considerably better than sleeping on the ground until the men began to pile the furniture in front of the door. Then she realized that they were afraid of the Indians, and she couldn't sleep a bit all night. "I just lay there and expected those babies to be scalped before morning," she recalled.

But morning came, and the babies cried safely. The men got up from the floor and stretched and moved the furniture away from the door. Mrs. Heacock went out to the wagon to get some things for the babies, and every single thing that could be moved was gone. That made the rest of the trip even worse for her.

"As if we hadn't had hard enough of a time already, that day we were right in the middle of a river when the wagon began to sink. Quicksand. It had been a good fording place the year before, but the sands shift. The men took off their shoes and socks and rolled up their trousers and carried me and my two babies and the girl to the bank. Then they hitched up the other four horses, and after a lot of splashing, heaving, and swearing they pulled out of there."

"I sure was exhausted when we finally got to Jemez with my two babies. But the flies there was such a sight, I made up my mind to go right back. They offered me every inducement they could think of to stay, but I had my mind all made up, and the next day I started back with my two babies on the stage.

"The first day I ate a lunch at a woman's house, and every bit of it was bad. The egg was bad, and the meat was bad. I got very sick, and the baby I was nursing got sick too. That kid just yelled and screamed continually, and the people on the stage were so mad they wouldn't speak to me. Finally, I got so sick that I made the driver stop and let me lie on the ground. The passengers were all wanting to put me back on the stage and get on our way for they wanted to get home. I never saw such selfish people. But the driver did what I told him. Finally, I became rigid, and then two women did get out and rub me until I was better and could climb back into the wagon. They said afterward I had a fit. But I never had a fit in my life. I was just plain sick and no wonder."

"We had stopped on one side of an arroyo, and we no more than got over that arroyo and a little way on the other side, when a wall of water as high as a three-story house swept down. It was a beautiful sight to see, but it sure would have dashed us and the wagon to bits if we had been in the middle of the arroyo a minute sooner. That gave us all a turn, and the people were more friendly to me the rest of the journey."

"I declare I thought I'd never go on a trip like that again, but the next summer we started off just the same."

Another story that was told by Mrs. Heacock took place in 1895 between Albuquerque and Jemez. The Native Americans mentioned in the story were from the Zia Pueblo, and that was where Mrs. Heacock and her family spent the night. The river she suggests is probably Jemez Creek, although Mrs. Heacock was not sure:

Mr. Heacock was always loyal to his clients, and they liked him. Though lots of people censured him for things, he did. Another time I remember, they were gambling and needed some money, and they brought in ten Chinamen to the night court. Two o'clock in the morning it was, and the deputies went out and rounded up those ten Chinamen. They hadn't done anything, I suppose, but the night sergeant counted what money they had in their pockets, and then Judge Heacock fined them almost that much for disorderly conduct. He always left his victims enough for breakfast. "Cruel and inhuman" I told him, but the Chinamen never said a word. The Judge knew the first one they brought in. "I'm sorry, John," he said, "but it's the mandate of the law hanging over your head." And after he had fined that one, he said, "Bring on the next queue."

Mrs. Heacock laughed. "I used to get mad at him when he came home and told me those things he'd done, and people did censure him."

"Still," she went on, "he was better than some of those that censured him. His clients thought a lot of him. He defended thirty-eight or forty accused murderers and never lost but two of those cases."

I remembered what Mr. George Klock, who had opposed Mr. Heacock in many cases said to me about him: "He was irregular—a bit erratic. But he never broke his word, and he was a brilliant man. If he had cared a little more about his health and his morals, he would have made his mark high. As it was, he had a following that was as loyal to him as subjects to their king."

Perhaps it is only fair to mention some elements of the more serious side of Judge Heacock's career. The judge graduated from Annapolis in the days when graduating classes were minuscule. He studied law in Philadelphia. He also performed one of the first surveys of the harbor at Rio de Janeiro. Mrs. Heacock said that he had many jobs offers to leave Albuquerque for a

A side street in Old Town, 1930. *Library of Congress.*

variety of positions in all parts of the country. However, life in New Mexico evidently suited him best. He was known as a successful defense lawyer and appeared in more murder cases on the docket of the Bernalillo County courts than any other attorney in New Mexico. Among the men who asked for his aid was William Bonney (aka Billy the Kid).

THE WAYWARD PRIEST

One of the most famous and controversial priests of the San Felipe de Neri Catholic Church was Padre José Manuel Gallegos. He served as the church's pastor from 1845 to 1852. Gallegos was known for his unorthodox lifestyle, and his independent nature made him a frequent source of concern for political and religious authorities.

José Manuel Gallegos was born in Abiquiú, northern New Mexico, on October 30, 1815. His father, Pedro Ignacio, was the alcalde and chief

magistrate of the town. As a young man, Gallegos attended a parochial school in Taos that was operated by Padre Antonio José Martinez. He became interested in theology and may also have attended a private school in Abiquiú. Later, he studied for the priesthood at the College of Durango in Mexico during the Mexican Revolution. Immersing himself in secular politics as well as sacred texts, he was ordained in 1840.

Soon afterward, José Gallegos got into trouble with Governor Manuel Armijo, who accused him of having an affair with the wife of a corporal in the Mexican army. Gallegos was sentenced to a three-year exile from Santa Fe. However, his superior, a vicar, interceded and sent him to the parish at San Juan to avoid any further controversy. In October 1845, Gallegos left San Juan and journeyed to Albuquerque, becoming a priest at the church in Old Town.

During his tenure at the church in Old Town Albuquerque, Padre Gallegos gained a reputation that was not consistent with being a priest of the Catholic Church. He was often seen drinking and gambling with many of the town's elite citizens. He rode about town in an elegant carriage accompanied by several attractive women, and he smoked expensive cigars.

The controversy grew as he was in business with a woman who already had three children, two of whom were from previous affairs with two Mexican officers. Although she claimed to be his housemaid, she was probably his mistress as well.

Together, the pair operated a general mercantile store, which, to make matters worse, ignored the policy of the church to observe the Sabbath. The store was open every Sunday, to the dismay of many of the locals. The padre also owned a wagon train. Several times a year, he would transport goods to and from Mexico. Together, the two businesses made him a wealthy man. The 1850 census showed his combined assets totaling $8,000.

Bishop Jean Baptiste Lamy and J. Projectus Machebeuf, Lamy's vicar general, arrived in Santa Fe in 1851. The Catholic Church placed the territory under the religious control of the U.S. Catholic hierarchy, and Pope Pius IX chose Lamy to manage the job in the newly created Santa Fe diocese. Lamy lacked a sense of humor and was a strict disciplinarian. He was appalled at the laxness of the Catholic Church in New Mexico and with the disobedience of some of its priests.

Gallegos proved to be an easy mark for Lamy, who questioned his competence, loyalty and integrity. Several times he warned Gallegos that his extracurricular activities and business ventures were a detriment to his duties as a priest of the Catholic Church. Gallegos refused to recognize

Wicked Old Town

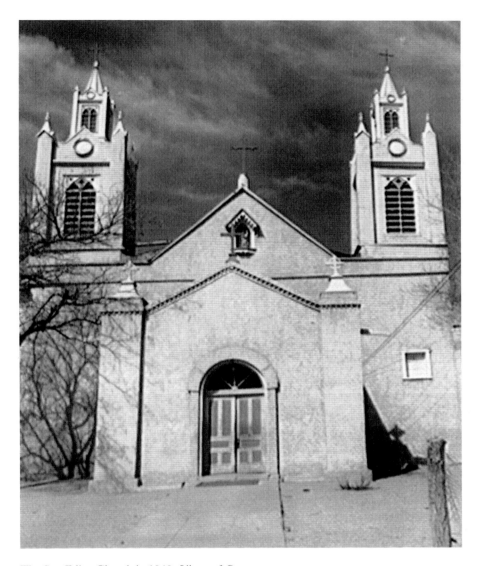

The San Felipe Church in 1940. *Library of Congress.*

Lamy's authority until a formal transfer of power occurred. He insisted that any accusations of improper behavior were exaggerated. By January 1852, Lamy had finalized the transfer of power, yet many local priests still considered him to be illegitimate. As a result, Bishop Lamy began to replace the New Mexican clergy with priests and nuns from other territories. Their job was to keep an eye on the insubordinate priests like Gallegos.

Later, in the summer of 1852, Gallegos departed Albuquerque with his wagon train to deliver merchandise and other goods to Mexico. His absence from the church was quickly noted, and word was sent to the bishop. Lamy took immediate steps to replace him, claiming that Gallegos had left his parish to travel to Mexico without official permission.

Lamy sent Father Joseph Machebeuf to Albuquerque to take charge of the church. The congregation was shocked to hear that Gallegos had been suspended and that Father Machebeuf was the new priest. As if to add insult to injury, Machebeuf even moved into the parish home that Gallegos had occupied.

However, the congregation was not happy with the sudden change. Lamy and Machebeuf had underestimated Gallegos's popularity among the church members. A formal protest was signed by 950 members of the church demanding that Gallegos be reinstated. They complained that they found Machebeuf's sermons to be boring and annoying and that the new priest was not in touch with the local community. Bishop Lamy ignored the complaints.

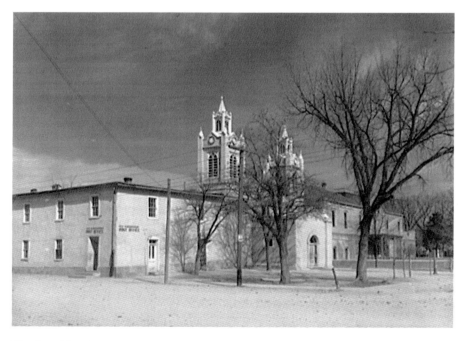

The San Felipe Church showing the location of the post office in Old Town Albuquerque. *Library of Congress.*

In early 1853, Gallegos returned from his trip to Mexico only to discover that he had been removed from the clergy. In an act of defiance, he announced that he would conduct Sunday services in the church as usual. Machebeuf, who was away from Albuquerque visiting nearby missions, quickly learned of the impromptu sermon and rushed back to the town. As he later wrote:

> *I returned to Albuquerque on Saturday night, on Sunday morning I went to the church and earlier than usual to be on the ground and ready for anything that might happen. What was my astonishment Upon arriving there to find the Padre in the pulpit and the church filled with people which I knew to be his particular friends. These he had quietly gathered together, and now he was inciting them to revolt or at least to resistance.*
>
> *I tried to enter the church through the sacristy but this was communicated with the presbytery which he still occupied, and I found the doors locked. Going then to the main door of the church, I entered and assuming an air of boldness I commanded the crowd to stand aside and make room for me to pass.*
>
> *Then, as one having authority, I Forced my way through the crowd and passed by the pulpit just as the Padre pronounced the bishop's name and mine in connection with the most outrageous accusations and insulting reflections. I went on until I reach the highest step of the sanctuary, and then turning I stood listening quietly until he had finished. Then all the people turned to me as if expecting an answer.*
>
> *I replied, and in the clearest manner refuted all of his accusations, and I showed, moreover, that he was guilty of the scandals that have brought on his punishment.*
>
> *To finish, I called upon him to justify himself, or at least to answer, if he had any reply to make. But not a word. He went out as crestfallen as a trap Fox and left me in peaceful possession of the church. I sang the high mass as usual, and preached the gospel of the day without making the least allusion to the scene that had just taken place.*

The sermon coup was devastating to Gallegos. In addition to leaving his parish without permission, Bishop Lamy added the new accusations of attempting to rally support among the parishioners of the church against Machebeuf. And, based solely on rumors, he was charged with violating his vow of celibacy. Lamy's suspension was final, and Gallegos was no longer a priest of the Catholic Church.

However, this was merely a new beginning for José Manuel Gallegos. During his priesthood in the 1840s, Gallegos had also been moonlighting as a legislator. By the time of his dismissal as a priest, Gallegos had put together an exceptional political career.

He served in the First and Second Departmental Assemblies of New Mexico from 1843 to 1846. A year later, Richard H. Weightman did not run for re-nomination as a delegate to the Thirty-Third Congress. Seeing an opportunity, Gallegos ran for the vacant seat as a Democrat. He gained Weightman's endorsement and the support of the New Mexico clergy. His opponent, William Carr Lane, was New Mexico's territorial governor.

Lane's campaign strategy to defeat Gallegos was to align himself with the former priest's religious rivals, Lamy and Machebeuf, in an attempt to discredit him by bringing up his alleged improprieties. Their hope was to divide and conquer his base of Hispanic Catholic voters by showing that he was morally unsuited for the office.

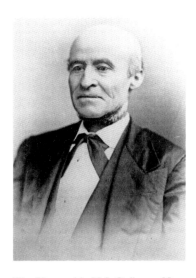

The Honorable J.M. Gallegos, New Mexico's first delegate to the U.S. Congress in 1853. *William A. Keleher Collection (PICT 000-742-0055), Center for Southwest Research, University Libraries, University of New Mexico.*

Soon after Lane's acceptance of the Republican nomination, the *Santa Fe Weekly Gazette* noted, "If they had selected a priest of good standing, the people would have no cause for complaint but to select a priest, who is suspended for the grossness of his immorality, is to our conception, insulting to the voters of the Territory, as it is disrespectful to the Bishop and the Church."

The article also questioned Gallegos's citizenship and ridiculed his poor English: "If he knew the English language, he could give vent to such insignificant ideas as may be supposed to arise in heads as small as his, but as he does not know the language, he cannot have the poor privilege of speaking nonsense."

In September 1853, Gallegos prevailed and won the election by 445 votes, despite the defamatory allegations of Governor Lane. On the other hand, Lane contested the outcome of the election, claiming that Gallegos did not meet the citizenship requirements at the time of his election. The

law required that a candidate had been a U.S. citizen for at least seven years. However, the committee threw out the allegation because Gallegos would have been granted U.S. citizenship under the Treaty of Guadalupe Hidalgo.

Lane then claimed that voter fraud and ballot miscounts caused his loss in many counties. He pronounced that many of Gallegos's votes were cast by Mexican citizens and Pueblo Indians, who were not U.S. citizens at the time, and as such, those votes should be disqualified. The Elections Committee looked into his allegations and eventually rejected almost four thousand ballots. However, it also determined that "these irregularities did not affect the substance of the election."

In the following years, Gallegos served as Speaker of the Territorial House of Representatives, territorial treasurer and the New Mexico superintendent of Indian affairs. He did this in spite of the fact that he did not speak English well and was not allowed to have an interpreter with him on the floor of the House.

After the Confederate occupation, Gallegos also served as foreman of a grand jury in a U.S. District Court that indicted twenty-four New Mexicans for cooperating with the Confederacy during the invasion of the territory. Gallegos's former opponent Miguel Otero was suspected of collaborating with the Rebels. Although Otero was not indicted, he fled with his family to Missouri in 1862. After the Civil War ended, all the cases were dismissed.

Continuing his controversial ways, Gallegos, at the age of fifty-three, married Candelaria Montoya, a thirty-one-year-old widow, in 1868. Their marriage lasted until his death on April 21, 1875.

Part III

WICKED NEW TOWN

In 1880, one of the city's most influential forces arrived: the railroad. Las Vegas, Santa Fe and other New Mexico towns fell victim to the piratical practices of the railroad baron, but Albuquerque welcomed the Iron Horse with open arms, hearts, wallets and a two-hundred-foot-wide right-of-way. With the railroad came sober, reliable businessmen. They intended to have safe, respectable homes for their wives and children and an environment that would appeal to home builders, and before many years, Albuquerque had become a comparatively peaceful place. After the coming of the railroad, there was even more lawlessness for a while. By 1891, the population of Albuquerque was four thousand. The town had twenty saloons and two banks—one that went bankrupt during the Panic of 1893. The city also had as many as twenty-four gambling establishments. Even after the 1900s, occasional stage holdups still occurred, and by 1903, there had been several cases of school money embezzlement by the city's officials. Oddly enough, Old Town, the original town site, was not incorporated into the "City of Albuquerque" until 1950. These are the stories of some of the more infamous characters who epitomized the controversial side of "New Town" Albuquerque.

Wicked New Town

The Lilly of Copper Avenue

One of Albuquerque's most famous madams was Lizzie McGrath, who ran the Vine Cottage at 312 West Copper Avenue and Third Street.

Mary Elizabeth "Lizzie" McGrath was born in Kentucky in 1862. She was the daughter of an Irish immigrant who was a carpenter and a Civil War veteran. When she was fourteen years old, she was attending a finishing school when she ran away with a contractor for the Santa Fe Railroad. The reasons for her leaving Kentucky in this manner have been distorted over time, but there are three distinct possibilities.

The census records show another birth in the family in about 1875. The infant, named Mae, is believed to be Lizzie's daughter. There is speculation that the father was a man who had lived with the family for several years, and this might have been the reason for her departure to New Mexico. Another theory suggests that she had already been a prostitute plying her trade in Kentucky and the railroad contractor was merely a means by which she could get out of town.

When the man abandoned her in Albuquerque in 1880, Lizzie turned to prostitution to make a living. Her first job was at Gertie Oliver's Wine Room, where she worked with several other young women. Under their tutelage, she quickly learned the business. Determined and ambitious, McGrath soon dreamed of owning her own bordello. She saved and invested her money wisely, and within three years, she was able to open her house. It was called the Vine Cottage. The building itself was just a clapboard-style house that had five parlors for entertaining and five bedrooms in the back for business. She employed two girls, Jenny Adams and Minnie Hall, as well as a cook and a Chinese laundryman.

In spite of her profession, Lizzie was an astute businesswoman. She understood the value of public relations and put much of her wealth back into the community by donating to the territorial fairs and various charities. As a result, she was very well liked by the community. This was vital to the existence of her business, as just around the corner from her brothel were some of the homes of Albuquerque's most respected citizens. Due to her charitable nature, these upstanding residents looked the other way and coexisted with the madam of Vine Cottage. Another variable that played into her hand was that she had a "regular job" working as a cashier at a local hotel. In 1899, the local newspaper printed a story on how she and another employee of the hotel aided in the arrest of a fugitive:

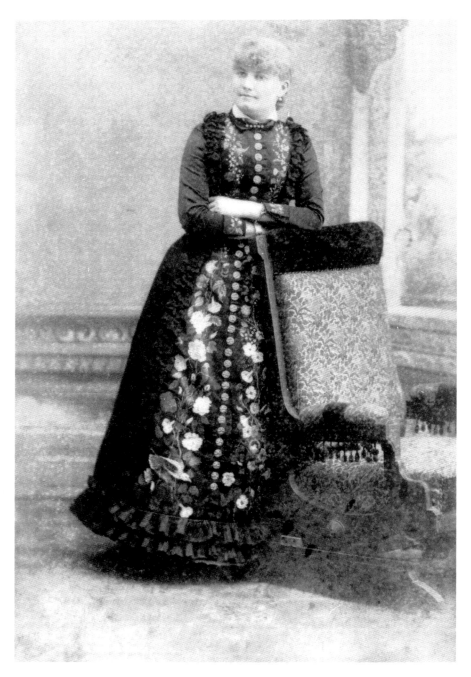

Lizzie McGrath, the Lilly of Copper Avenue. *Albuquerque Museum.*

> *H.B. Ekcam, a swindler who has achieved almost a national reputation by the daring of his operations in Ohio, New Mexico and Kansas, escaped from the Holton jail today and has disappeared as though the Earth had opened up and swallowed him. Ekcam, a year ago, swindled Eli Nedeau out of a sum of money at the time estimated to be $4,000. He was apprehended in Albuquerque New Mexico by Lizzy McGrath and H.R. Curtis, of that city, both formerly being residents of Topeka.*
>
> *Ekcam was a partner in The Firm of Nedeau & Co., a trading concern located on the Pottawatomie Indian Reservation, which does an immense business with the wards of the nation. His knowledge and connection gave him the opportunity to Swindle on a gigantic scale, and he did not neglect it. Money secured, Ekcam, with his wife, absconded and entered Albuquerque as a fugitive. Curtis saw him at the Depot and recognized him, and Miss McGrath, who is the cashier of the hotel at which Ekcam and his wife registered, also recognized him.*
>
> *Ekcam was under the influence of alcohol. He talked freely with Miss McGrath, acknowledged that he had been in Kansas and displayed a watch he had stolen from a Topeka Jeweler. Miss McGrath and Curtis notified the authorities, who at once communicated with the authorities at Topeka. His arrest followed, and he returned to Kansas.*

Unlike the other madams, who kept their clients' identities a secret, Lizzie openly sued those who neglected to pay their debts regardless of whether they were prominent men or her own working girls.

In 1908, one of the girls working for her, Fay Tanner, managed to take a large sum of cash from Lizzie's business and attempted to flee the state. The *Albuquerque Journal* reported the outcome of the theft and the girl's capture. "Woman of Doubtful Reputation Arrested in El Paso and Will Be Returned to This City for Hearing" read the headline of the article. It continued:

> *Charged with the theft of cash and notes to the amount of $1,000 or over, a woman of the demi-monde named Fay Tanner has been arrested in El Paso on advices from the police department of this city and is held there pending the arrival of an officer from this city to bring her back for a hearing. Two warrants have been issued on complaint of a woman named Lizzy McGrath alleging grand larceny and embezzlement. The woman is said to have left here five days ago for the Pass City with the proceeds of her alleged thefts. An attorney has been employed to prosecute the case, and the woman will likely have a hearing the latter part of this week.*

However, the notorious madam could be quite understanding as well. When her own cook and handyman, Joe Kee, stole a large sum of cash from a bank deposit and went on a gambling spree, Lizzie tried to have the charges dropped. Kee was sentenced to two years in prison but was pardoned after fifteen months.

On occasion, Lizzie's attempts to run a clean house were thwarted. In 1885, the *Albuquerque Journal* reported that a local businessman had become drunk and passed out in a room of the brothel. Two hours later, the gentleman awoke to the sharp smell of chloroform. Disoriented and very irate, the man started to create a ruckus. Lizzie was awakened, and a search was soon conducted to discover what was going on. It was soon found that a hole had been cut into the screen of the window where the gentleman had passed out. It was plainly visible that an attempt was made by someone outside the house to render the gentleman unconscious and rob him.

In 1886, an ordinance was passed about the houses of ill fame, punishing the madams and the girls with fines of $5 to $100, ninety days in jail or both. The law proved so difficult to enforce that it was repealed in 1887, and a code of conduct for prostitutes was created in its place. Among the provisions of this ordinance it was ruled that no "common prostitutes" could publicly ride a horse or ride in an open buggy between 7:00 p.m. and 9:00 p.m. Apparently, madams were not exempt from these rules either, as Lizzie and a man named Jack Dickson were arrested for riding in an open sleigh on Central Avenue one evening in December 1909.

They were also forbidden from wearing lewd or indecent dress, including the "Mother Hubbard," a favorite among many of the prostitutes because it was a conservative type of dress with one main exception: the demure dresses, which stretched from the neck to the ankle, were made of a transparent material that left little to the imagination.

While Lizzie was liked by the citizens of Albuquerque, the same could not always be said of her competitors. By 1886, Major Henry Jaffa and the city council had passed legislation that placed regulations on the red-light district. One of these regulations would soon be quite a grievance to McGrath's business enterprise.

On November 26, 1905, the *Albuquerque Journal* published the formal legal notice against Lizzie:

> *That during the said term of Court affidavit had several conversations with the said district attorney in regard to the occupation and use of certain property located in that quarter of the City of Albuquerque known as hell's*

WICKED NEW TOWN

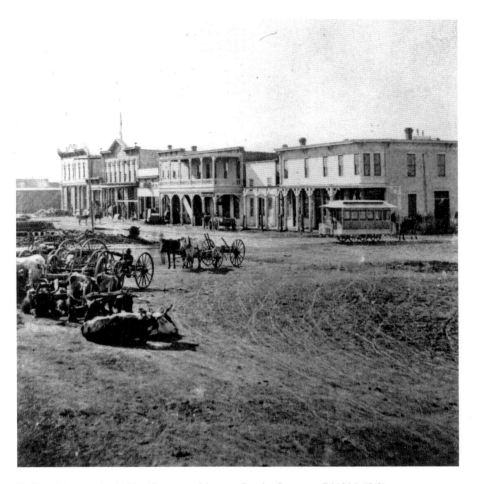

Railroad Avenue in 1880. *Albuquerque Museum, Creative Commons (PA1990.13.2).*

half-acre between the Masonic Temple on 3rd Street and the Lutheran Church on the same street. That the property along said Street was then and is still pretty generally occupied and used for places of prostitution. Some of these places being dives of the worst kind. That in that District, within 700 feet of the Masonic Hall and the said Lutheran Church are the principal and most of the notorious houses of prostitution in the city such as the houses of Lizzy McGrath, Minnie Carroll, and Nelly Driscoll; that the house occupied by Minnie Carroll is owned by A. Viviani and is leased by him to one L. Gradi and subleased by said L. Gradi to Minnie Carroll who runs a house of prostitution therein. That the complaint had

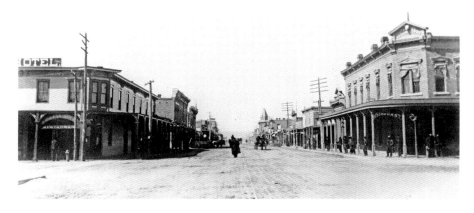

Looking down Railroad Avenue (now Central Avenue) to First Street in Albuquerque, circa 1890. The building on the left is the European Hotel, operated by Frank Sturgess. The Metropolitan Building, on the right, was built in 1885. The building with the tower in the distance on the right is the Grant Building, which housed Grant's Opera House. *William A. Keleher Collection (PICT 000-742-0534), Center for Southwest Research, University Libraries, University of New Mexico.*

> *been made to the said district attorney by one of Albers and other Trustees of the said Lutheran church located on 6th Street and within 700 feet of which nearby all of said houses of prostitution are located especially the one so occupied by Minnie Caroll; So that one Joe Badaracco also rents houses to women to be occupied for purposes of prostitution that said Alders and trustees of said Lutheran Church has demanded the enforcement of chapter 84 of the acts of the legislative assembly of 1901 and as amended by chapter 113 of the acts of the legislative assembly of 1903 on account of the said church and proximity of the set houses of prostitution to the same.*

The charges were severe, and the financial loss that would come from losing their businesses was simply too great. Lizzie, Minnie and Nelly joined forces and hatched a plan to thwart the indictment. They met with the leaders of the Lutheran church and offered them a sum of $3,000 for the church and the land it sat on. The offer was a substantial amount of money in 1905, roughly $7 million in today's currency. The church would have been foolish not to accept the offer. After a small discussion, the church leaders took the money.

Once the deed to the church and land was in their hands and the congregation had moved out, the united madams implemented the final part of their plan. Despite protests from the locals, construction crews soon arrived at the site and began demolishing the Lutheran church.

With the building gone, their brothels were once again in compliance with the law.

Similar circumstances threatened her second brothel that she tried to open at 222 West Copper Avenue in 1910. The newest bordello was too close to the Masonic Lodge, violating the zoning regulations set forth by the city. This time, Lizzie tried to take a legal approach and hired an attorney.

In 1911, Lizzie McGrath appealed the case to the New Mexico Territorial Supreme Court. McGrath and her lawyers attempted to persuade the justices that McGrath had been wrongfully convicted of violating the following New Mexico statute:

> *That every person who shall set up or keep a brothel, bawdy house, house of assignation or prostitution, in any town, city or Village in the territory of New Mexico, within 700 feet of any schoolhouse, college, seminary or other institution of learning, or any church, Opera House, theater, hall of any benevolent or fraternal Society, or other place of public assemblage, on conviction thereof, be adjudged guilty of a misdemeanor.*

The post office in New Town Albuquerque. *Library of Congress.*

McGrath, according to the conviction, had established her business on West Copper Avenue in New Albuquerque between Third and Fourth Streets. This location was within seven hundred feet of the halls of both the Masonic and the Knights of Columbus fraternal organizations and the Pastime Theater.

A primary feature of the trial was proving that McGrath did indeed operate a brothel from her home on Copper Avenue. The list of witnesses set to testify against her was vast and even included her cook. One of the witnesses stated that it was common knowledge that McGrath operated a house of prostitution. He went on to claim that female customers to his saddle and harness business had complained to him about the prostitutes in the area and had voiced their reluctance to continue visiting his store. "I have been told," he said, "by women frequenting my place that they do not like to come there on account of their being around the houses of prostitution…around there on that street." Another witness was asked if he had ever seen women standing or walking immediately outside McGrath's; he replied, "Every time I pass or walk in the vicinity, I will see somebody around there."

Although McGrath's attorney made good points in refuting many of the testimonies against her, she lost the case and was forced to close the brothel.

The fate of Lizzie's original brothel was eventually determined by the mayoral election of 1914. Democrat D.K.B. Sellers was in favor of keeping the red-light district as opposed to having the prostitutes scattered all over the town. His opponent, Republican D.H. Boatright, wanted the district closed altogether. The *Albuquerque Morning Journal* campaigned for Boatright, who won the election. The ordinance outlawing the red-light district took several months to complete. When it was finalized, the city marshal was instructed to close the ladies down. While the mayor received a few threatening letters demanding that he reopen the district, he stood his ground and made prostitution illegal. McGrath closed up shop and left Albuquerque for an extended vacation. When she returned to the Duke City in 1917, her Vine Cottage had become a boardinghouse.

Lizzie died in 1921 while she was standing in line to make a deposit at the First National Bank. She was buried in her hometown of Topeka, Kansas. She died a very wealthy woman. When crates were opened at her estate, the auctioneers found pouches of uncut diamonds, emeralds and rubies; gold coins; and all sorts of other artifacts. The building that housed the Vine Cottage was eventually torn down. The Hyatt Regency Hotel now occupies the site of the infamous house of ill repute.

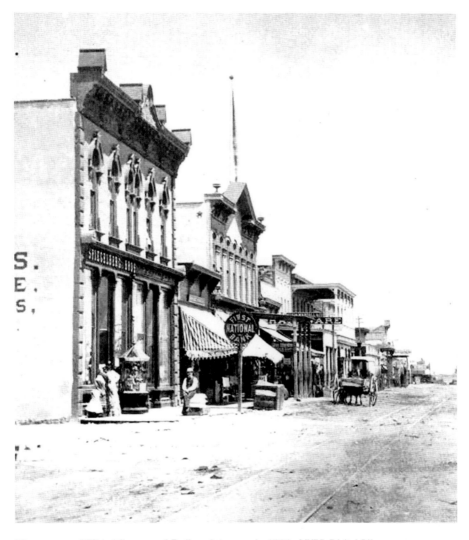

The corner of Third Street and Railroad Avenue in 1880. *NYPL Digital Library.*

In a remembrance of its unusual downtown heritage, the Hyatt Regency Hotel once housed McGrath's Bar and Grill. When the restaurant was closed in 2011, the hotel employees held a mock funeral by lowering the McGrath's restaurant sign into a coffin. The coffin was then placed on a horse-drawn hearse that was accompanied by a bagpiper and a large group of "mourners."

The Murderous Sheriff

John Armstrong was born in Walnut Ridge, Arkansas, in 1849. He was a rebellious youth who began his life of crime in his twenties when he was accused of murdering a man in Sharp County, Arkansas. After the local sheriff posted a $200 reward for his capture, John fled the county to escape the consequences. However, he continued making poor career choices, as he was soon implicated in yet another murder, this time in the town of Helena. Not wishing to stand trial, he was soon on the run again.

He eventually teamed up with two of the most infamous outlaws of the region: "Mysterious" Dave Mather and Dave Rudabaugh. They went on to form a rustling gang that terrorized cattlemen all the way from Fort Smith, Arkansas, to Texarkana, Texas. Things began to escalate after the gang murdered a prominent cattleman during a robbery in Arkansas. The gang was soon on the run and fled into Texas. The three separated, and Armstrong ended up in Texarkana. However, by 1875, he was beginning to feel trapped and watched as the growing rewards for his capture appeared in public. One day, while he was walking down the street, he noticed that another man seemed to be following him. Believing that he was a bounty hunter, John whirled around and shot him dead. The man turned out to be an innocent bystander who had simply made the mistake of following John Armstrong too closely.

Armstrong rode back into Texas and soon joined the Texas Rangers. He honorably served in Company B of the Frontier Battalion until 1876. Perhaps seeking to turn over a new leaf, he arrived in Decatur and soon opened a saloon and pool hall with the help of a partner, Bob Jones. He had changed his name to John Johnson, and with associates such as John Henry "Doc" Holiday, Tom Pickett, "Big Jim" Duncan and Hyman "Hoodoo Brown" Neil, there is little doubt about the reputation he was earning. However, his time in Texas was short-lived. A bounty hunter was on his trail and was roaming about the town asking questions about the Sharp County murder. Armstrong, taking no chances, sold out his half of the business to his partner and quickly left town. The unfortunate bounty hunter was found dead on the outskirts of Decatur a few days later. His body was shot up almost beyond recognition.

After spending a short time in Dodge City, Kansas, he moved to Cañon City, Colorado. He had by now changed his name to Milton J. Yarberry. Again he decided to go into business, and with the help of a partner, Tony Preston, he opened a saloon and variety theater called the Cañon City Gem Saloon. The theater hosted several notable performers of the

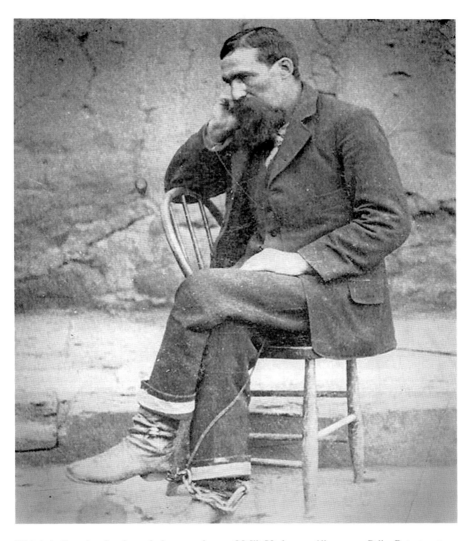

This is believed to be the only known photo of Milt Yarberry. *Albuquerque Police Department.*

time, including the great vaudeville performer Eddie Foy. Along with his partner, Jim Thompson, Foy played at the theater and saloon in 1879. In his memoirs, Foy described Yarberry as "citified and prosperous appearing in a broadcloth suit, velvet vest and a frilled shirt front with a white collar." He wore expensive eastern-made boots and sported a long black mustache. Foy also added that he was "none too sweet of a character."

Eddie also recalled that when they finished the run of the show, they were told that there was not enough money to pay them. Yarberry owed them several weeks' pay, and the performers were not about to tempt angering the gunslinger directly. So, unable to collect, Jim Thompson stole a barrel of whiskey "as payment for services rendered" and sold it. Aware of Yarberry's reputation, Foy was amazed at Thompson's courage but was quite grateful for the cash.

On March 6, 1879, the bartender of the Cañon City Gem Saloon shot Yarberry's partner, Tony Preston. The bullet passed through Preston's chest, entering his body just above the right nipple and exiting near his spine. Yarberry fired three shots at the bartender but missed. Later, Yarberry joined the posse in pursuit of the renegade bartender, who then surrendered to the town marshal.

Yarberry departed Cañon City shortly after that, selling his half of the saloon to Preston. He followed the crews of the Santa Fe Railroad, who were building new rails to the south. Yarberry, along with a female partner known only as "Steamboat," operated a brothel that catered to the construction crews and the "boom camps" they created. The pair eventually ended up in Las Vegas, New Mexico, where they established a more permanent house of ill repute. Business was great for a while, but Yarberry was soon on the wrong side of the law again. He became a suspect in the murder of a freight hauler but was able to avoid any charges based on a lack of evidence. In 1879, he shot and killed a man named John Morgan in the Rincon Hotel. The murder was allegedly over a prostitute, but Yarberry escaped prosecution because it was done in self-defense.

With this latest string of events, Yarberry was growing tired of Las Vegas, so when he discovered that his old partner Preston had moved to San Marcial, he decided to join him. He sold his share of the brothel and moved yet again. Preston, who was still recovering from being shot earlier in the year, had brought his wife, Sadie, and their four-year-old daughter in the hopes of opening up another saloon. However, Yarberry's intentions appeared to be entirely different.

While operating the saloon in Cañon City, Yarberry was having an on-and-off affair with Sadie. Apparently, he was interested in becoming reacquainted with Tony's wife. Several months later, Yarberry left San Marcial. Sadie Preston and her daughter went with him.

In 1880, the couple moved to Albuquerque, where Yarberry befriended Bernalillo County, New Mexico sheriff Perfecto Armijo. With Armijo's

support, Yarberry ran for election to be Albuquerque's first town marshal. He defeated his opponent, J.H. Robb, by a landslide with a vote of fifty-five to nineteen. However, it should be noted that Milt's name was the only one that was printed on the ballot, as Robb was a write-in candidate.

For a year, things were quite peaceful, but that was about to change. In 1881, Harry A. Brown, a self-proclaimed gunman, drifted into town. Brown had played a small role in impeding Dave Rudabaugh and his gang from committing a robbery near Kinsley, Kansas. Although there is not a record of him having shot anyone, he loudly boasted about how many men he had killed and how proficient he was with a gun. Naturally, Brown soon gained a bad reputation in Albuquerque. He was a heavy drinker with a short fuse and would draw his weapon with little to no provocation. He was a former express company guard and the son and nephew of two former governors of Tennessee.

By February 1881, Brown had become acquainted with Sadie Preston, and the two became romantically involved. The tension felt by the community was recorded in the *Albuquerque Journal*:

> *At the time there was in the employ of the Adams Express company, as route agent, Harry Brown, a young man of fine physique, good, decent, genteel and brave. His father was ex-governor Neil Brown, and his uncle ex-governor John C Brown of Tennessee. We had also a woman of the half world known as Sadie Preston, who was Brown's steady company when he was off duty, and whose favors were courted by the Marshall [sic] when Brown was on duty and the way was clear. We who were posted could foretell the storm. These men met and spoke and drink together, at every meeting we looked for tragedy, but with opposite results to those which occurred when it was enacted.*

On the night of March 27, 1881, Brown and Sadie were having dinner at the Victoria Restaurant on First Street. Sadie had left her young daughter at home with Yarberry, who was unaware of her budding relationship with Brown. According to John Clark, the coach driver, shortly after the couple entered the restaurant, Yarberry came walking up the street with Sadie's daughter. Brown, hearing that Yarberry was just outside the restaurant, walked outside and waited by the doorway. Yarberry walked right past him, taking the little girl inside. A few minutes later, he came back outside, alone, and began speaking with Brown. According to Clark, the two began arguing and became increasingly irate.

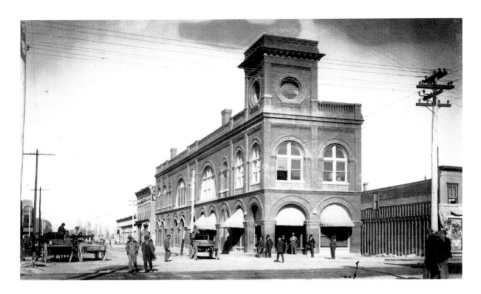

Northeast corner of Second Street and Central Avenue in Albuquerque in 1915, showing the building that was constructed for the Zeiger Café. *William A. Keleher Collection (PICT 000-742-0539), Center for Southwest Research, University Libraries, University of New Mexico.*

The two men walked down the street to a vacant lot. As they passed Clark, the coach driver overheard Brown telling Yarberry that he was not afraid of him. Clark figured that Yarberry had threatened Brown with his position as town marshal. Suddenly, Sadie Preston came out of the doorway of the restaurant and called for Brown. With Yarberry distracted by Sadie, Brown hit him in the face and drew his pistol. He fired once, grazing Yarberry's hand. Immediately, Yarberry drew his pistol and shot Brown twice in the chest. As he lay sprawled on the sidewalk, the marshal pumped two more shots into him. Brown died immediately

However, a contradicting story published by the *Albuquerque Journal* suggests that Yarberry fired first:

> We who rushed to the scene saw Yarberry moving away from the prostrate Brown, heard Brown's dying words, "Milt, you killed me cowardly," saw Sadie Preston rush to Brown's body, take his gun from the Scabbard beneath him and secreting it in her clothing, go away. So ended poor Brown. The body was taken to Adams Express office, 113 railroad avenue and in this, it was remarkable that from his manicured toenails to the dressing of his hair, except for the four wounds in his breast, it was as delicate and neat as that of a newly washed child.

This, of course, raises a question. Why did Sadie take and conceal Brown's gun? Shortly after that, Sheriff Armijo arrived and took Yarberry into custody. During a preliminary hearing, multiple witnesses testified that they heard Brown publicly announcing that he intended to kill Yarberry. Yarberry insisted it was self-defense:

> *When we reached the empty lot, Brown used some of the vilest language that he could lay his tongue to. He was, I could see, trying hard to get the drop on me. I had my back to the restaurant when I heard Sadie call to Brown. I did not look around and a moment later Brown struck me a blow in the face with his left hand, at the same time drawing his six shooter with his right, immediately firing his first shot hitting my right hand and inflicting a trifling scratch on the thumb. In an instant I realized that I must either kill him or die and quicker than it takes to tell, I whipped out my gun and began firing.*

Yarberry was eventually cleared on the grounds of self-defense. However, several prominent people in town expressed dissatisfaction with the results of the hearing, believing that the judge and jury had been bribed:

> *Yarberry was arrested but a suit of clothing and a farm wagon induced "Negro" Martin, the Old Town alcalde, to hold him justified. Upon trial, in the district court, $240 paid to the proper men on the jury bought a verdict of not guilty. The sporting element and the Bunco gang stood to their friend.*

In addition to attacks on Yarberry in the newspapers, they called for a grand jury indictment. It was granted and convened in May 1881. Yarberry's attorney, S.M. Barnes, produced a multitude of witnesses on Yarberry's behalf. Again the ruling was in favor of the marshal. On May 19, 1881, Yarberry was acquitted. However, it was a short-lived victory. Less than thirty days after the acquittal, Yarberry killed another man.

On June 18, 1881, Yarberry sat on the front porch of his friend Elwood Maden's home, conversing with gambler Monte Frank Boyd, when they heard the crack of a gunshot coming from the direction of the Greenleaf Restaurant. The two were heading down the street toward the restaurant when they saw a man walking briskly down the street. Yarberry asked a bystander who had fired the gun. The observer pointed to the man who was walking away. Yarberry and Boyd ran after him. The marshal yelled at him, telling him to halt and that he wanted to speak with him.

The man walking down the street, Charles D. Campbell, soon lay dead, killed by three bullets fired by Boyd and Yarberry. Boyd immediately fled the town, but Yarberry surrendered himself to Sheriff Perfecto Armijo. The story that Milt gave to the sheriff was entirely predictable. He claimed that Campbell had turned toward him and pointed a gun at him. Thus, he fired in self-defense. However, one of Campbell's bullet wounds was on his back. Yarberry explained that the bullet in the back had come as a result of Campbell's body being spun around after the first shot hit him in the front. Although Campbell was thought armed, no one could testify that Campbell had drawn his gun. It was later established, however, that Campbell was unarmed. Again Yarberry was cleared in a preliminary hearing. The *Albuquerque Journal* published an article soon afterward that recorded the reaction of the town's population:

> *For the next few days after the killing, Albuquerque was the scene of greatest excitement. Meetings of indignant and excited citizens were frequent, but cool heads and wise counsel did much toward quieting the hot-headed populace, and this, by Sheriff Armijo, prevented Yarberry from being tried in "Judge Lynch's" court.*

Campbell's funeral had a large turnout, and the mood of the town seemed very hostile toward Yarberry. For the safety of his prisoner and to prevent any possibility of the irate citizens of New Albuquerque taking matters into their own hands, Sheriff Armijo had Yarberry transferred to the jail in Santa Fe to await his Bernalillo County Grand Jury appearance. The Santa Fe jail was known to be the most secure jail in the territory. Yarberry was eventually brought to trial a year later, in May 1882. The grand jury ruled that he would stand trial for murder. Meanwhile, Yarberry would remain in custody at the Santa Fe jail. The trial lasted for three days. Yarberry stuck with his story that he had shot Campbell in self-defense. However, testimony from a Nebraska attorney, Thomas Parks, presented the former marshal with most damning evidence. Parks testified that he saw Yarberry shoot Campbell in the back after he had stopped and held up his empty hands.

The jury retired for only ten minutes before returning a verdict of guilty. The following month, Yarberry was sentenced to hang. A reporter from the *Albuquerque Journal*, who was on the scene, wrote:

> *He* [Yarberry] *appeared not the least affected until the last words of the judge, "and may God have mercy on your soul," were pronounced, when his*

WICKED NEW TOWN

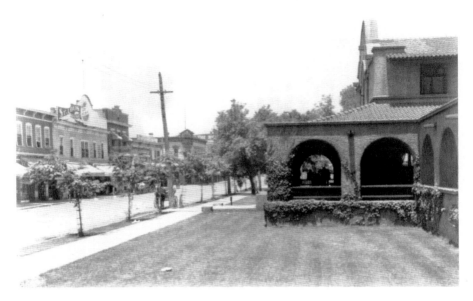

Railroad Avenue near the area of Campbell's murder. *Library of Congress.*

face suddenly turned a livid hue and his cold, great eyes flashed out darts of malice toward the judge as he said: "Judge, I have not had a fair trial, you have not treated me justly. The men in New Town who tried to hang me [in the Brown case] *have falsely sworn my life away."*

His defense lawyers acted swiftly. In a series of lengthy appeals, including one to President Chester Arthur, Yarberry tried to dodge the hangman's noose. Not satisfied with the legal results, Yarberry chose to escape from confinement. On September 9, 1882, he teamed up with three other convicts. They had filed through their shackles and attacked the jailer, thrown a blanket over his head and then tied him up. The foursome quickly discovered that a $500 bounty had been placed on them. The other inmates were captured quickly, while Santa Fe County sheriff Romulo Martinez put together a posse to apprehend Yarberry. He was arrested three days later just twenty-eight miles from town. Five months later, his appeal was denied.

On the morning of February 9, Yarberry was brought to Albuquerque by a special train under the guard of the Governor's Rifles, a New Mexico militia group. A *Journal* reporter recorded the scene:

> *Most of the time on the way down, he [Yarberry] kept his eyes turned towards the window of the car seeming anxious to drink in as much of the outer world as possible. He was very talkative and kept up an almost incessant conversation with Sheriff Bowman. He talked about his case and of the great Injustice that had been done to him. He spoke privately with the sheriff about some of his relatives but said nothing upon any subject which related to anything or anybody but himself.*
>
> *A reporter on the scene was said to have remarked: "From the way you are being guarded, Milt, one would think that you were a second Billy the Kid."*
>
> *"That is done by my enemies," he replied, "This is all they can do. They have sworn my life away and now want to show off."*

At 10:20 a.m., the train arrived at the depot in New Town. More than two thousand people had turned up to get a glimpse of the former marshal. Yarberry was loaded aboard a horse-drawn streetcar and transported to the jail in Old Town. As he entered the courtyard, Yarberry would have had his first look at the newly designed gallows that awaited him.

The origin of the device is quite unknown. However, the belief was that this form of hanging was more "humane" than the traditional method. In the traditional gallows, the condemned climbed thirteen steps to a platform that contained a trapdoor through which he would be dropped. However, the "hanging machine" employed a massive crossbar over which was balanced a long beam. At one end of the beam, the condemned man stood on the ground with a noose around his neck. At the other end was an enclosed structure in which a four-hundred-pound counterweight was held aloft by a rope. When the line was cut, the weight dropped, causing the prisoner to be jerked up into the air and to his death. The *Journal* reporter continued his story:

> *Upon arrival at the jail, Yarberry was placed in a cell and immediately his old friends and acquaintances in Albuquerque were applying for admission. He kept in constant Conversation during the time he was waiting for the announcement that his time had come. He showed signs of weakening at different times, and then he would break up and appear to be himself again. He ate a lunch consisting of some cranberry pie and drank a pint of whiskey and a bottle of Ale.*

Father Persone and Father Fede baptized Yarberry in his cell and administered his last rites. The condemned man expressed his belief in the

Catholic Church and made a confession. Yarberry was confident that a respite would arrive from Washington in time to save his life. In a last act of kindness, his friends purchased a new suit of black clothes for his final hours on earth.

At twenty minutes before three o'clock, the guards were ordered to their posts, and the crowd was pushed back to a line east of the gate leading to the yard. The sheriff tied the prisoner's hands behind him, and the procession to the gallows was started. It was headed by Sheriff Armijo, who had Yarberry in tow. Chief Howe and Deputy Sheriff George Munroe brought up the rear. Upon reaching the gallows, Chief Howe read the death warrant. Yarberry, during the reading, kept his eyes on the officer and seemed emotionless. After it had been concluded, he stood erect and eyed the crowd that faced him, and he launched into a long and passionate speech about the history of the events that led to his death sentence. He maintained that he was justified in killing both Brown and Campbell. When told his time was running out, Yarberry replied, "Let me finish," and went on with his last words. The *Albuquerque Journal* recorded what followed:

> *At precisely half a minute before 3 o'clock, his hat was taken from his head, his feet having previously been bound together, the noose was adjusted and he was compelled to stop speaking. The black cap was drawn over his face by Archie Wilson. A second before the signal was given, Yarberry said: "Well, you are going to hang an innocent man."*
>
> *Scarcely had these words escaped his lips when the signal was given, the Rope which held the weight was cut, and Yarberry shot into the air. The jerk was so sharp and sudden that his head struck the crossbeam of the scaffold and he again dropped until he took up the slack in the rope and remained dangling in the air. The man's neck was broken by the shock and the crackling of the joints could be plainly heard. As soon as the body swung to the ground, Dr. Derr and Dr. Sawyer of Albuquerque and Dr. John Symington of Santa Fe rushed to the gallows and, cutting loose the rope, found the hands of a hanging man, felt his pulse, which was found to be beating. With each passing minute, the pulse grew weaker. Death ensued at the ninth minute.*

By 3:10 p.m., Yarberry was declared to be dead. His body was cut from the scaffold and placed in a narrow coffin. The black cap was removed from his face. According to eyewitness accounts, his eyes were open and glared up at the crowd with a blank stare. His jaw had dropped down to his breast.

Milt Yarberry's tombstone. Its current location is unknown. *Albuquerque Police Department.*

The lid was nailed on the coffin and was then carried to the San Felipe Catholic Church, where the funeral services were held. Afterward, his casket was taken to Santa Barbara Cemetery and buried.

After his death, Yarberry's supporters continued to state that he was unlawfully condemned. They believed that he was only convicted due to the will of the more prominent and influential citizens of Albuquerque for damaging the reputation of the town. It was claimed that Sheriff Armijo said, "Innocent or not, it mattered little to the prominent people of the town, who were more concerned with the town's image."

Today, the location of Yarberry's grave is unknown. A tombstone that once marked the location of his grave was removed and for many years was stored in the San Felipe Church. The general area of the cemetery where his grave should be is covered by three feet of sand.

Hell's Half Acre

The very first instances of prostitution in Albuquerque are linked to the presence of Fort Marcy. The fort was located west of the Old Town Plaza and existed between 1846 and 1867. Like other towns in New Mexico, ladies of the evening were always on hand to entertain the soldiers who brought them valuable business.

The two largest brothels in Old Town were owned by Mariano Martin and Sim Ovelin. To keep the peace and share the wealth, they forged an agreement to alternate hours of operation. They believed that this arrangement would fairly divide the potential profit of their bordellos. The problem with the agreement is that their employees often did not follow it. One November evening in 1881, music and loud voices could be heard coming from Ovelin's establishment. This was a problem because it was occurring during Martin's hours of operation. So, Martin walked

over to have a word with Sim. When he entered the building, he found his girls soliciting customers inside. Martin immediately ordered the women to leave. However, the women were having such a good time that they defiantly declined. Such defiance coming from the mouths of his employees infuriated Martin to the point of violence. He pulled out his six-shooter and began hitting the women on their heads with it. A huge fight almost started but was averted when Sim entered the building with profuse apologies. Apparently, he had mixed up the schedule of when his business was supposed to operate. Since there was no damage done, except to the thick skulls of the prostitutes, the incident was forgotten.

Martin was well known for abusing and beating his employees. His wife, known as Santa Fe Mary, once gave him a severe stab wound. In 1883, he pistol-whipped her after an argument at their home, resulting in a ten-dollar fine and enough public outcry that Martin was forced out of Old Town a month later.

In its early years, Old Town was a violent place, and the houses of ill repute were highly responsible for that. The proprietress of a wine room near the Exchange Hotel was the object of affection between two cowboys who were passing through town. The two men had a shootout over her, but fortunately, both of them were too drunk to hit anything.

In October 1881, a man named John Connors visited Martin's brothel and saloon, Mariano Martin's. As he waited at the bar for a drink, he was approached by two soiled doves named Marinda and Minnie. The girls wanted John to buy them a drink. However, John was not interested and was very blunt in telling them so. When he turned back toward the bar, one of the girls pulled a knife and stabbed him in the back. While Connors's wounds were very severe, he did survive the incident. On the other hand, the two girls were arrested and could not pay the $500 bond that the judge put on them. Martin refused to pay the bond as well, so the girls went to jail for the stabbing.

In some circumstances, the girls were not prosecuted at all if the interests of the business were not affected. A good example of this occurred in December 1881 at Sim Ovelin's place. That evening, two of the working girls, Georgie Smith and Maud Eddie, got into an argument over a wealthy customer. Georgie pulled a derringer from her petticoat and fired at Maud. The bullet glanced off the steel frame of her corset and whizzed into the wall. The noise of the shot immediately drew a crowd. During the noise and confusion, Georgie slipped out of the saloon and then skipped town. Maud only received a flesh wound, and the matter was hushed up without any arrests being made.

Right: The restaurant sits on the former location of Madam Kate Fulton's Old Town Dance Hall, circa 1882–83. *Library of Congress.*

Below: The building on the left was the location of W.T. Armstrong's Saloon, 1881–83. *Library of Congress.*

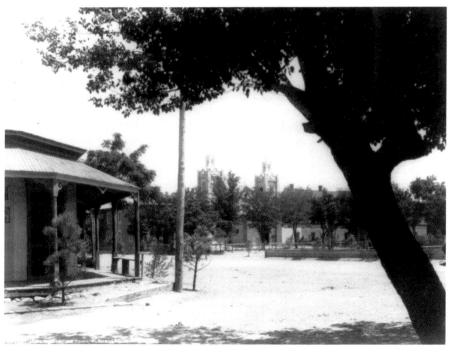

Another famous bordello in Old Town was owned by a woman called Rumalda Griego. It was a simple three-room building that had up to three beds per room. Often the ladies entertained their customers simultaneously in the same room. Madam Rumalda was hauled into court on numerous occasions, most often on charges of being a public nuisance. Deputy Sheriff Cornelius Murphy once testified that he had witnessed multiple men sharing beds with the women in the house.

An alley running south of the plaza provided discreet access to many of the bordellos, saloons and gambling joints. Eventually, this alley would become Morris Street. One of the more famous brothels that was accessible through this alley was owned by Madam Maggie Morris. Maggie opened a wine room there in 1882. Her wine room would eventually become the largest bordello in Old Town. Her working girls included Gertie Oliver, Anna Burke, Belle Springer and Jennie Morgan. Gertie Oliver would eventually open her brothel in New Town and would train many of Albuquerque's notorious madams.

When the railroad arrived from the north in 1880, it immediately took up the rapid transport of goods and passengers who had previously come in along the Santa Fe Trail, fueling a new prosperity and growth in the territory. Unfortunately, the Rio Grande was too close to Old Town to allow the installation of the tracks. As a result, the railroad tracks were built several miles to the east of the Old Town site. The city was divided as "New Town" sprang up near the newly constructed railroad. Oddly enough, the name "red-light district" is believed to have its origins with workers of the railroad. The men had to carry red lanterns when they left the rail yard just in case there was an emergency. The crew caller would then be able to find them. These lanterns were left outside the bordellos when crew members stopped to pay the ladies a visit and sometimes were brought inside and placed in a window.

Naturally, the ladies of the evening saw the opportunity for more business in New Town Albuquerque, and the transition from Old Town to New Town began. By 1885, the ladies of the night had practically abandoned Old Town. Five brothels and five wine rooms were functioning in New Town. For the most part, the brothels appeared respectable. Some had picture bay windows and long porches from which the girls could solicit their customers. Entertainment was the key to these houses, and they often employed pianists to play waltzes and other traditional Victorian music. Because most of the houses possessed liquor licenses in the name of the madam, they were euphemistically known as "wine rooms." The interiors of these houses were

often richly furnished with red plush parlor sets, expensive oriental rugs, Brussels carpeting, marble-top tables and many mirrors. The residents of the better houses were called "demi-monde," "nymphs du pave" and "women of easy virtue."

By 1891, the red-light district supported seven parlor houses but, surprisingly, no cribs. The business in the region was so lucrative that within two years the number had drastically changed. In 1893, only four parlor houses remained to directly compete against ten privately operated cribs: the Gem, Vine Cottage, Rose Cottage and Nora's.

By 1882, the competition had become so fierce that the residents of the houses began going out on the streets to solicit more business. Part of this seems to have been due to the establishment of the cribs where older or less attractive prostitutes serviced the clientele in an assembly-line fashion at cheaper rates. While the public had no objection if the madams and girls stayed in the red-light district, they strongly objected to them infiltrating the main streets.

The effect of this was recorded in the *Albuquerque Journal* on March 23, 1882:

> *There are altogether too many houses of prostitution in this city, and if it were possible, they should be suppressed. If there is no way of clearing the city of this class of establishment altogether, the officers should at least see that they are conducted with as little publicity as possible.*

On April 16, the *Journal* noted:

> *Two or three prostitutes have fallen into the habit of exhibiting their ugly mugs about the city in a hack, and by their obscene actions attract the attention and disgust of respectable citizens. They should be suppressed.*

The citizens and the newspaper stopped short of asking for the closure of the district and the expulsion of the women. Too many leading citizens were no doubt among the clientele, and the taxes from the liquor sales were beneficial to the city.

The girls in New Albuquerque rarely paraded about in states of undress, as the city's parlor houses were more sophisticated than those in Old Town. In saloons and restaurants, girls wore Japanese-style kimonos with burning sticks of incense called punk in their hair or favored conservative dresses known as Mother Hubbards. It was an entirely different story for the girls

who worked the cribs. Their actions would eventually create more regulation of the industry.

When the girls were not entertaining customers, they usually drank and picked fights with one another. The newspapers considered a good fight to be newsworthy, especially when it concerned the girls. On July 30, 1885, the *Journal* noted:

> *Marshal Ostrander's attention is called to the noisy female loafers who congregate in and around the Dancehall. About three times a week several of these "soiled doves," by inclination, fill up with tarantula juice and make nights hideous by their pugilistic tendency to fight and scratch among themselves.*

In 1886, the ordinances governing the red-light district were drafted. This law would eventually be so difficult to enforce that it was repealed a year later. It was replaced with a code of conduct for prostitutes. Among other rules, they were forbidden to wear a rude or indecent dress, ride in an open carriage or be out between midnight and 6:00 a.m. without a good reason. Loud conduct, indecent displays and vulgar language were expressly forbidden. Violation of any of the provisions in the law was punishable by a $100 fine.

With this last bit of civic attention, the whole issue seems to have been settled. The girls had their district, and the town had established how it expected them to behave. Business went on as usual.

Another incident reported by the *Albuquerque Journal* in 1882 shows more of the violent side of Hell's HalfAcre:

> *Andy Schultz, a blacksmith, who has recently been engaged in thumping music out of a piano in one of the houses of ill-fame on Railroad Avenue for the amusement of the guests and inmates of the place, boozed up yesterday. In the afternoon, while in the Ben Ton Saloon, a man called him outside, and as soon as he reached the street struck at him with a knife, inflicting a cut in his throat, and ran away. Schultz re-entered the saloon, and with the assistance of one or two men went to Pinger & Co.'s drug store and had his wounds dressed by a physician. On examination, it was found that there was a horrible gash across the throat and several small cuts about the face. He bled profusely, but the cut was not deep enough to be dangerous. Schultz says that he had never before seen the man who attacked him, that he had no quarrel with him and did not know what his motive could be.*

Marshal Lou Blonger arrested a man shortly after the incident. He had a razor that had bloodstains on it, and he told the marshal that he was afraid of being lynched. However, he refused to give his name. Blonger almost had the man confessing that he had committed the crime. However, Schultz was too drunk to properly identify him.

In many cases, the violence was directly related to the opium dens that operated in the red-light district. The opium dens, also called hop joints, had to operate covertly due to the constant persecution and investigation by newspaper reporters and law enforcement. In the 1880s, there were seven hop joints operating in Hell's Half Acre. One was located in a "mysterious tent" near the post office on Second Street. Another was hidden in the backroom of the Wing Sing Laundry on Railroad Avenue. A man known only as "Cuing" operated another in an alley running between Copper and Railroad Avenues. It was a simple structure made out of rough lumber with a tented roof.

A Chinese immigrant called "Charlie Jew" operated in a long one-story adobe building north of Copper Avenue. The building had two small

An Indian enclave near Hell's Half Acre. *U.S. National Archives and Records Administration (523032).*

entrances on the west side that were covered by curtains. Another immigrant named "Doc" ran a den near First Street. The sixth was located in Old Town and was managed by a man named "Quong."

The majority of people who hit the pipe were prostitutes and gamblers from Copper Avenue and the Third Street red-light district. However, it was quite difficult for an unknown Occidental to gain entrance to a hop joint. The safeguards of admittance were reminiscent of those used later by the Prohibition-era speakeasies. A reporter for the *Albuquerque Morning Journal* described the entry process on May 13, 1882:

> *A loud rap on the door leading to the private room of the establishment created quite a stir among the visitors and the celestials of the establishments. After waiting a considerable time, a Chinaman opened the door and inquired, "who's there?" We told him a friend when he replied, "go to the front door." The Chinaman glanced at a notebook in the reporters pocket and then looked at the owner in a suspicious manner. He refused to impart any further information and imitated by gestures his desire that the reporter should leave.*

The interior of the typical opium den was described by another reporter of the *Albuquerque Daily Journal*. His story, printed on December 6, 1881, gave a detailed portrayal of the illicit establishments:

> *The furnishings of opium dens were simple and usually consisted of low benches, couches or bunks, curtained rooms, and the paraphernalia of smoking. On either side was a large bunk and huddled upon these were five smokers, enjoying the pipe. In the center of each bunk was a small alcohol lamp, which was used in cooking the drug and lighting the pipe.*

The same newspaper also gave a description of the paraphernalia that was associated with the habit:

> *An opium smoking outfit comprises a tray, a headrest, pipe, and Bowl attached, a lamp for lighting for pipe, a bowl cleaner, a needle for adjusting the Opium Bowl, a pair of scissors, a sponge and a shell. The bowl of the pipe is held over the lamp while smoking it, the smoker being in a reclining position with his head firmly fixed on the headrest.*

The drug was sold to the addict in small and expensive quantities. Typically, it was shipped to America in seven-ounce tins. One reporter noted

A typical opium den. *Library of Congress.*

that "it was brought in on a card and had the appearance of molasses." Opium smoking was an expensive habit but was easily within the financial reach of most of the madams and prostitutes. Typically, they made three to five times more than the average skilled laborer. Fifty cents was enough to purchase enough opium for fourteen pipes.

The majority of the addicts would smoke between twenty and one hundred pipes per day. This cost them anywhere from $0.70 to $3.50 per day to maintain the habit. The newspapers of that time were often astonished by the sheer number of men, women and even children who could be found in the dens on any given day. They were places of "easy sociability" where the fringes of society could congregate and "hit the pipe." In 1883, a reporter from Albuquerque conducted an interview with a gambler and a prostitute in an attempt to understand their side of the story:

> Hundreds of people who daily traverse the streets of this young giant Metropolis have not least idea of the extent to which this cursed habit of opium smoking is carried on here. Stranger to the fact is not aware that the young man whose hand he has just warmly shaken, and passing him on the street, is an opium fiend of the most irredeemable sort. His unnatural motions and the strange appearance of his eyes is ascribed to other causes.

In the course of conversation, one of the smokers said that if it were known who frequented this haunt that a great commotion be made in society, for some of the most respected ladies, gentlemen and even young girls are in the habit of indulging themselves in the pipe.

Although smoking opium was illegal in Albuquerque, law enforcement would often look the other way. Perhaps the cause was the influence of so many of the city's notable citizens indulging in the habit. Another article printed in 1885 reflected the issue, as a reporter wrote about what happened when he managed to gain entry into one of the hop houses:

As we enter the room, there was a scampering of many feet as if a number of persons for hiding under the bunks, but we were a little too soon for some of them, who lay with dazed stupid expressions of their countenances. Two of them were women who were commonly known as "soiled doves." The other two were young men who figure behind the commercial counters, who begged us, not to give their names in the paper.

The opium dens were often portrayed by the press as being scenes of debauchery, gambling and other unspeakable vices. While in some cases this may be true, the reporters sold more newspapers if the facts were amplified by their creative writing skills:

It is a fact that there are at least three Mongolian Dives in Albuquerque in which the practice of opium smoking is openly conducted. Opium smoking is confined to Chinamen and a few degraded Caucasians that were initiated into the practice before coming to this city. It is also said that these dens are used as fences for stolen property, and a more degrading vice than the use of the pipe is practiced. Behind the darkened windows of the houses, the scenes of debauchery enacted at times are said to be fearful when the maddened brutes fling off their restraint. The reporter is informed that a dissipated female, half stupefied by opium was made to pose with various attitudes at one of the houses recently for the delectation of the bestial patrons.

The fate of Albuquerque's red-light industry and its opium dens was determined by the mayoral election in 1914. Republican D.H. Boatright was determined to permanently close the district. When he became mayor, he set out to do just that. Within a matter of months, he passed legislation that made prostitution illegal. Some of the girls moved back to Old Town,

which still lacked laws against prostitution. However, this was short-lived, as legal prostitution was outlawed there in 1920.

Today, nothing remains of Hell's Half Acre. However, there are many legends about a place called Haunted Hill. Located at the northeast end of Menaul Boulevard, it is rumored to be full of the ghosts of murdered prostitutes. There are many stories associated with the hill, told by visitors who were brave enough to venture up there after dark. Many of them say that the hill is haunted by the apparition of an old man who once lived in a cave at the top of the hill. On the weekends, he would come down from the hill into town and entice prostitutes back to his dirty abode. Once he had the woman inside his cave, he would murder her and bury her near an arroyo.

The apparition carries a lantern, and supposedly it can be seen at night, swinging back and forth as it moves down the trail. People also claim that you can hear screaming, footsteps and the sound of bodies being dragged down to the arroyo. The interesting thing is that there are older legends about this area that may have helped to create the Haunted Hill legend. While details of the story vary from storyteller to storyteller, this is the basis of the legend.

Long ago, there was a hardworking man who had a terribly nagging wife. She regularly spent more money than what was brought into the household, and she complained about practically everything that he did—he was lazy, he didn't make enough money, he couldn't cook, he couldn't fix anything right. Day and night, her nagging ensued, making the man's life a living hell. He seldom argued in his defense, for he had learned that it was only a waste of time and often made things worse.

However, the poor man had one blessing. He often trapped game up in the mountains, and he owned a small cabin up in the foothills where he could have peace and solitude. After a while, it no longer mattered if he even caught anything, as he enjoyed the blissful hours alone while he checked his traps.

One weekend, he was preparing to leave for the cabin when his wife decided that she would accompany him. "I know that you're wasting time up there. I'd bet that you do nothing but sleep anyway," said the wife. "How do I know what you do up there? This time I'm going to keep an eye on you." The man was quite distraught. He knew that his week of peace was doomed. His only hope was that his wife would find the rustic conditions of the cabin so horrible that she would leave the next morning.

He was in for quite a disappointment. When the man and his wife finally arrived at the cabin, she did indeed complain about the conditions. However,

she made it quite clear that she was staying and began forming a list of "chores" that needed to be done to the property. "I knew it! Look at this rat hole! You and your lazy ways!" she harped at him. She scattered about the cabin with a disgusted look on her face.

"I have traps to set!" he protested. But his words fell on deaf ears. "Well, you can't set traps after dark, so you'll do the chores then!" she coldly replied. For the next several days, the poor man labored. In the morning, he would set off to check his traps, enjoying the brief amount of privacy that it gave him. In the evening, he did the chores around the cabin, ever under the watching eye of his wife.

Finally, the day came when he had to check the traps that were set farther up in the mountains, requiring an overnight camp away from the cabin. His wife was up to her typical complaining, and never in his life had he looked forward so much to sleeping on the cold, hard ground. "Stay close to the cabin," he warned her. "The arroyos around here can become mazes, and it's quite easy to get lost."

His wife took the remark as an insult. "I can take care of myself, and I'll wander wherever I please!" she snapped back. Once again the man bit his tongue, quickly gathering his things and departing, his wife's complaining voice gradually fading off as he went along.

Content with his solitude, the man took his time checking the distant traps. A two-day excursion turned into three. Finally, on the third day, he set off back toward the cabin. "Hello!" he called out when the cabin came into view. But there was no answer from his wife. "Hello!" he called again as he swung open the door, looking inside. However, his wife was not there.

The grate of the fireplace was cold, no meal was prepared and it became evident that his wife had wandered off and become lost. He chuckled. Finally, he could argue that he was right about something. Feeling free and in good spirits, he lit a fire and began to make a meal for himself. As he moved a kettle over to the fire, he suddenly felt a cold chill race through his spine. There in the flames was the face of his wife, looking menacingly at him. As he stared in disbelief, the spectral image spoke to him.

"Stuffing your face instead of searching for me to give me a decent burial! You lazy dog!"

"Burial?" the man gasped as he moved backward.

"Find me!" sneered his wife. "You sniveling..."—before she could finish her insult, the man grabbed a cup full of water and threw it on the flames. With a loud hiss, the fire sputtered out and the flaming head vanished. With a sigh of relief, the man sat at the table, alone once again. Suddenly, he no

longer felt hungry. Could his wife be dead? Somehow that thought made him feel odd, even happy. She was gone forever!

Then, off in the distance, he heard the loud clap of thunder. The spring monsoon had arrived, and a wall of black approached the cabin from the river valley. The hour was getting late, so he decided to lie in bed while the storm passed. Then he would decide what to do.

The frigid rain violently struck the cabin as the wind howled and shrieked, carrying the screeching voice of his wife with it. "Find me, you lazy dog! Find my body!" The man put his fingers in his ears and yelled back at the ghostly voice, "Leave me be!" Rocking back and forth, he started humming, trying to drown out the specter. But the voice only grew louder. "You're wasting time. Get out and find me!"

Finally, the man could stand no more. He knew that he would not be able to rest until he found the body of his wife. Grabbing a lantern and lighting it, he grudgingly walked out into the pouring rain, following the sound of the ghostly voice. "Find me...," the wife's voice wailed in the distance. The rain made it practically impossible to see, and several times he almost lost his footing, sliding downward toward one of the arroyos. This is what must have happened, he thought to himself. She must have fallen down into one of the arroyos and died.

The wind picked up, and the rain pelted his body in waves of cold, making it difficult to pinpoint the exact location of his wife's shrieking voice. Just when he thought that the voice was getting closer, it would suddenly change direction. Sometimes it was off to the left and at other times it seemed to come from behind. Then, very quickly, it became quite clear: "Find me! Find me, you worthless bastard!"

The voice was louder and seemed to come from his left. He turned and stumbled as he slid deep down into a wet arroyo. The lantern fell from his grasp, landing in a small stream of water, extinguishing it. "I can't find you!" he yelled into the wet darkness. There was no reply.

The wind blasted down through the arroyo. Then, there it was, very faint—her voice. At first it sounded like she was laughing, a laugh that was gradually building up into a scream. He fumbled about in the mud, trying to turn around. He was confident that he had finally found her. The noise grew louder as he glanced over his shoulder. The last thing he saw was a wall of water as it ripped down the hillside. The arroyos are known to flood. They are known to be deadly.

It has been many years since then. Few wander around the Haunted Hill at night, but those who do often hear a woman's voice on the wind.

Sometimes they may even see the ghost of an old man who is doomed for eternity to look for the voice of his lost wife, his spectral lantern swaying wildly as he crosses from one arroyo to the next.

BALLOONS, DAREDEVILS AND DEATH

Park Van Tassel was born in 1853 in Cass County, Indiana. The son of Rufus Van Tassel, he eventually moved to Albuquerque, where he opened up the Elite Saloon in New Town. As a boy, Van Tassel saw his first balloon ascension at a fair in Ohio. Fascinated by the thrill of flight and the moneymaking potential of such an endeavor, he decided to try it himself now that he had the available capital to do so.

He soon purchased a balloon from a company in California. It was constructed of goldbeater's skin, a fabric that was made from the intestines of cattle. The balloon was fastened to the wicker gondola by a net of hemp rope and would require thirty thousand cubic feet of coal gas to completely fill it. He named the balloon "The City of Albuquerque" and planned the balloon's maiden voyage as part of the Fourth of July festivities the city was holding at the fairgrounds.

To help promote the event, Van Tassel gave himself the title of "Professor," and the name stuck—that is, until several years later, when he finally promoted himself to the rank of "Captain."

The announcement of the first balloon ascension in the state of New Mexico spread rapidly. The *Albuquerque Journal* ran a series of short statements that Van Tassel paid to have printed. One such announcement appeared in the newspaper on July 2, two days before the planned flight:

> *BALLOON ASCENSION*
> *By Prof. Van Tassel*
>
> Under the direct patronage of the people of Albuquerque, Tuesday, July 4, 1882 Prof. Van Tassel will superintend the inflation and make the perilous ascent accompanied by a reporter of the journal, who agrees to give a full and correct report of their experience while "up in the balloon."
>
> By all means witness the thrilling and exciting sensation as the aeronaut takes his place in the fragile basket: The perilous start and the noble and Sublime scene of the great ascent up among the clouds. A balloon ascension

invariably leaves a strong, lasting and Vivid impression upon the mind and memory. It attracts all classes, old and young, all tastes and interests; for a balloon ascension is at all times a novel and sublime sight, exhibiting, as it does, man's domination over the very air he breathes. As a spectacle, it fixes the attention of every beholder. As an achievement of science, it is one of the greatest and grandest ever witnessed.

On the morning of the fourth, the streets of Albuquerque were flooded with people arriving for the festivities. Although the majority of the events were in Old Town, many headed to see the balloon being inflated. The launch was scheduled at 10:00 a.m., but there was a problem. The balloon was filling up too slowly. Many of the spectators left to see the other events in Old Town, skeptical that a launch would even take place.

By late afternoon, the balloon was only three-quarters full. Not wanting to disappoint the visitors who had come to watch the ascension, Van Tassel announced that the launch would take place at 6:15 p.m., even if the balloon was not completely filled.

At the appointed time, Van Tassel climbed into his wicker gondola accompanied by John Moore, a local reporter who was to ride in the balloon with Van Tassel to chronicle the historical event. When the balloon failed to ascend, Moore had to step out.

A balloon owned by Arthur Van Tassel being filled for flight as a large crowd looks on. *Cobb Memorial Photography Collection, 1880–1942 (PICT 000-119-0743), Center for Southwest Research, University Libraries, University of New Mexico.*

Wicked New Town

The event was covered in detail two days later by the *Albuquerque Evening Review*:

Early Tuesday morning the City of Albuquerque commenced presenting a lively appearance. People flocked in from all directions. They came in wagons, on horseback, on foot and many more used burros as means of conveyance. Where all the people came from could not satisfactorily be told, but they were here bent upon celebrating Independence day. The city itself was appropriately decorated, and the stars and stripes swung from many a flag staff. Music floated upon the air from many places, and the crack, crack of firecrackers could be heard in every direction. Saloon men did an immense business, and the efficient police force which had been appointed for special duty succeeded in keeping those who drank too freely of the ardent from creating disturbances. There was no trouble during the entire day, and the quarrelsome ones, when they became too demonstrative, were taken care of without delay.

During the forenoon the crowd was centered on Second Street, between Railroad and Gold avenues, to witness the inflation of Professor P.A. Van Tassel's balloon. The balloon has a capacity of thirty thousand cubic feet and filled too slowly to satisfy the impatient crowd. As the hour advertised for the ascension came and passed and still no signs of the aeronaut starting on his journey, the people became restless, and a general buzz of dissatisfaction could be heard. They could not, or would not, understand the cause for the delay and many went so far as to assert that the voyage would not be made. It became apparent that the balloon would not be cast loose from its moorings before a late hour in the afternoon, and at about 1 o'clock a procession was formed and started for the Fair Grounds to witness the races and other sports which had been made up. Every street car was crowded to its utmost capacity for the next two hours, and the grounds were rapidly filled up.

Shortly after five o'clock word was telephoned to the old town that the balloon would start on its aerial flight at 6:15 precisely. This announcement was made from the grandstand, and the crowd again started for new town. Although the balloon was scarcely two-thirds full, Professor Van Tassel decided to risk the trip rather than disappoint the people who had waited so long to witness the ascension. At the appointed time everything was in readiness, and the bold navigator of the air stepped into the basket. It was found that the "City of Albuquerque" would not carry her captain with more than forty-five pounds of ballast, let alone any passengers, so she was turned loose with only him on board.

When the balloon still wouldn't rise, Van Tassel tossed a sandbag of ballast over the side that struck one of the spectators on the head, completely covering him with sand. The unfortunate spectator would eventually sue for the injuries he had received from the jettisoned sandbag. Slowly, the balloon then began to rise as Van Tassel gleefully waved an American flag at the delighted crowd. Later, he would describe looking down on the crowd to simply see "one black mass of humanity." When the balloon reached 11,000 feet, Van Tassel jettisoned more ballast, which, according to his onboard instruments, allowed him to reach an altitude of 14,207 feet. Fortunately, none of the discarded weight hit anyone on the ground this time. The newspaper article also noted the sudden rate of ascension: "The balloon rose high above the house tops and moved slowly to the south when it appeared to stop its lateral motion and went straight up among the clouds."

Park Van Tassel. *Library of Congress.*

With the increase in altitude, the air was becoming thinner and colder, something the Professor had not anticipated well enough. As he struggled to open a valve slightly to decrease his altitude, he inadvertently opened it too rapidly, triggering a rapid descent. Fearing a crash, he panicked and immediately began throwing anything he could overboard to slow his fall. His coat, lunch and water bottle all went over the side. The *Albuquerque Evening Review* describes what happened next:

> *Another current of air was struck, and the ship commenced to descend and landed safely in a corn field in the rear of the fairgrounds. As soon as it was seen just where Prof. Van Tassel would alight, quite a number of men started for the place on horse-back, and a Journal scribe obtained a conveyance in which to bring back the aeronaut and his balloon.*
>
> *The professor was found, none the worse for his voyage, busily engaged in emptying the balloon of the gas. This was soon accomplished, and the party with their ship safely loaded started for the new town arriving at the starting point at 9 o'clock.*

> *A grand ovation was awaiting the party at the Elite, and many and loud were the expressions of congratulations with which Van Tassel was greeted. All united in saying that the ascension was a success in every sense of the word.*

The news of the triumphant ascension traveled quickly, and within a week, Van Tassel was invited to another event in Las Vegas, New Mexico. This time, the spectators were charged a "subscription fee," which provided Van Tassel with a new form of income.

On August 15, 1882, Van Tassel attempted his second balloon flight. The work of filling the balloon started at 9:30 a.m. and proceeded nicely until all of the available gas was used. The valves were then closed to wait for the manufacture of more gas. The balloon was tossed about every time there was a breeze. However, it was steadily held in place by sandbags and other fastenings.

At three o'clock, a dark rain cloud appeared on the northern horizon, signaling an approaching storm. Nervously, managers anxiously watched the movements of the storm until four o'clock, when a strong gust of wind swept down over the ill-fated balloon, ripping it loose from its moorings. It sprang into the air like a rubber ball and bounced across the ground until it was caught on a fence that bordered the park. The canvas of the balloon was severely torn, causing all of the gas to escape. The damage was so severe that the flight had to be canceled. The paying crowd did not demand a refund at first, as they believed the unexpected storm was not Van Tassel's fault. Thus, he should not be held accountable.

One month later, Van Tassel was back in Albuquerque enjoying his newfound celebrity status by going out for a night on the town with a few of his friends. What occurred that evening made the news the following day in the *Albuquerque Evening Review* of September 12, 1882:

> *Early this morning a party of three men, Lou Blonger and Park Van Tassel being two of them, went on a sightseeing expedition and in the course of their rambles reached that unsavory portion of Fourth Street, north of Railroad Avenue, occupied for the most part by houses which sell virtue by retail. One of them, kept by Blonger's woman, the trio entered and began to amuse themselves, Van Tassel and the woman commencing a jocular conversation. Some remark used by Van Tassel angered Blonger, who without warning brought down his heavy stick on the aeronaut's head, following this blow by another and a heavier one with a long 45 revolver, which he drew immediately,*

in the same place. Springing back he then cocked the gun and threw it down on Van Tassel, with the exclamation,

"You s-- of a b----, you can't talk to my woman in that way."

Van Tassel had jumped up when struck the first time, but the second blow stunned him, and he fell to the floor. Blonger attempted no further violence, and the wounded man was taken to the office of a physician where his wounds were dressed.

This morning a warrant was issued for Blonger's arrest on the charge of assault with intent to kill. He was arrested, waived examination and was held over in the sum of 3500 to appear at the October district court.

Whether it was the fight or the desire to accomplish something grander, Van Tassel left Albuquerque and headed to San Francisco, California. The following year, he made his longest flight in an inflatable—exactly three hundred miles in a six-hour, forty-five-minute flight that conveyed him from Salt Lake City over the Wasatch Mountains.

In any case, ballooning wasn't Van Tassel's only interest. He was additionally intrigued by parachuting, a perilous affair that had already caused a significant number of fatalities in Europe. Constructing his own parachute from a diagram he found in a dictionary in a library, Van Tassel made his first jump in Kansas City. Sometime after the jump, Van Tassel married a woman who shared his love of adventure. Her name was Jenny Rumary Van Tassel, and she soon became the star attraction in Van Tassel's touring troupe.

Against all the odds, on July 4, 1888, Jenny was the first woman to make a parachute jump, and she did it from a balloon. It almost didn't happen after the practice runs with the balloon went horribly wrong. The balloon landed on the roof of a home belonging to a former mayor and demolished his chimney. The irate politician called the police, who then decided that it was in the best interest of public safety to cancel the balloon ascension.

However, Jenny outsmarted the detective assigned to keep her under house arrest. She made her way to the balloon and climbed into the gondola, where her husband was waiting. The balloon took off, and after rising to six thousand feet, Jenny Van Tassel made her historic leap. In a later interview with the *Los Angeles Times*, Jenny described her jump: "I ain't exactly a bird nor an angel, but it's just about what I imagine the sensation of flying is. It was beautiful!"

In 1889, Van Tassel had a rather close call when he was performing a parachute jump over the ocean near San Francisco. Just before going into

the water, he became tangled in the lines as the parachute blossomed before hitting the water. He narrowly escaped drowning. Undeterred by the incident, the Van Tassel troupe started on a world tour, during which they managed to create controversy at practically every show.

Protestors in India undermined him, frightful that his inflatable would "get them in awful" with the "air spirits." In Australia, the scant attire of Gladys and Valerie Freitas, two new hires of the Van Tassel troupe, created even more controversy. The young ladies performed in skintight outfits as they dangled from trapezes attached to the bottom of the gondola. They performed tricks and a few acrobatics before dropping to the earth underneath handcrafted muslin parachutes.

In any case, after an Australian show was seen by the whole Queensland Defense Force, officers feared that the enlisted men were so mesmerized by the scantily clad skydivers that they "would be beset with an outbreak of masturbation that would ruin their collective manhood."

Yet another scandal occurred in Hawaii when a member of his troupe ascended in a balloon from Honolulu to the height of four thousand feet. He floated out over the ocean about two miles from land and then descended with the aid of a parachute. The parachutist landed in the water, where he was devoured by sharks before assistance could reach him. Initially, it was believed that the man was Van Tassel's brother, Joseph, but further investigation revealed that the man who had succumbed to the sharks wasn't Joe Van Tassel at all. He was an Albuquerque man named Joe Lawrence. Lawrence was employed with the Van Tassel troupe and had taken on the name Joseph Van Tassel. Apparently, he was performing all the jumps since Park Van Tassel hadn't jumped since his near-death experience in San Francisco.

In 1892, Khwaja Ahsanullah, the Nawab of Dhaka, invited the Van Tassel troupe to perform during one of their grand celebrations in East Bengal. The arrangement was to have Jenny Van Tassel ascend in a balloon from the south shoreline of the Buriganga River. The balloon would then drift north of the waterway and arrive on the top of the palace roof at Ahsan Manzi.

A fire of wood that had been soaked in kerosene and lamp fuel created the hot air that filled the inflatable. Once the balloon was ready, the show started promptly at 6:20 p.m. on March 16, 1892. However, Mother Nature refused to cooperate. The winds were constantly changing in their intensity and direction. Rather than arriving on the royal residence rooftop, Van Tassel's inflatable crashed into a tree at Ramna Garden, about three miles

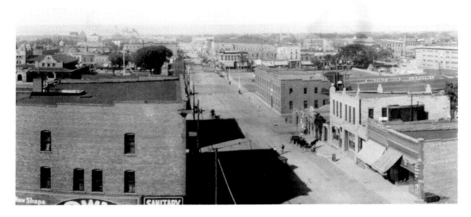

Looking down Railroad Avenue (Central Street) in 1895. *Library of Congress.*

away. The police quickly arrived and endeavored to save the performers by extending a bamboo pole to the balloon's gondola. As Jenny Van Tassel moved onto the pole and started to descend, the bamboo snapped, and she fell thirty feet to the ground. Severely injured by the fall, she died a few days later. She was buried at the Narinda Christian Cemetery at Dhaka.

After the unfortunate occurrence in East Bengal, Park Van Tassel left the balloon entertainment business. He died from heart disease on October 24, 1930, in Oakland, California, at the age of seventy-eight.

Part IV

THE WICKED ART OF WAR

The Civil War touched the city briefly when, in 1864, the Union claimed the territory for its own. Confederate troops occupied Albuquerque and installed eight defensive cannons to secure their hold. Once the war had passed, Anglo settlers, who had been slow to move in before, began showing a much greater interest and began arriving in force, mostly merchants, tradesmen, artisans, doctors and lawyers.

THE BATTLE OF ALBUQUERQUE

The prelude to the Battle of Albuquerque began with the Confederate occupation of the town. It started after the news of the Union defeat at Valverde reached the command at Fort Union. Immediately, measures were taken to contain and control the Confederates' movements. The Union plan was to engage the Rebels at Fort Union, which they considered to be a more defensible position. Troops were ordered to fall back from Albuquerque and Santa Fe, burning any supplies that they could not bring with them. Captain Herbert Enos, assistant quartermaster in Albuquerque, recorded the chaos that ensued as the Confederacy approached:

> *I have the honor to make the following statement relating to the abandonment and destruction of the public property under my charge at Albuquerque New Mexico. On the afternoon of the first instant, I received reliable information*

that a body of Texans, 400 strong, supposed to be in the advance guard of the enemy, had reached the town of Belen, 35 miles below Albuquerque. Upon this intelligence, I ordered that every preparation be made for destroying the public stores, both Quartermasters, and subsistence, which could not be carried off. At about 6 p.m. one of my express riders came in and reported that a party of about 50 had reached the town of Los Lunas and captured a citizen train, carrying public stores. I had in the meantime loaded what ammunition and Ordnance stores the ordnance agent, Mr. Bronson, deemed important to secure, started them on the road to Santa Fe. I had all the teams that were left, eight or nine, harnessed and ready for moving at a moment's warning, carrying the baggage of some militia and volunteer companies and 12 regular soldiers. The latter were my only dependence, and I had assumed command of them.

The night passed without the appearance of the enemy, but believing that he would soon be upon me, and not hearing of any troops being on the way from Santa Fe to hold the town, I gave the order to fire the property at 6:30 on the 2nd. The destruction would have been complete had it not been for the great rush of Mexican men, women, and children, who had been up the whole night, anxiously for an opportunity to gratify their insatiable desire for plunder. The only property that was not burned consisted of molasses, vinegar, soap and candles in the Subsistence Department, and a few saddles, carpenter tools, office furniture in the quartermaster's department. Most of these articles were carried off by the Mexicans.

The destruction of the stores involved the destruction of the buildings containing them, as it would have been impossible with the force and the short time at my disposal to have removed the property from the buildings in order that they might then be burned. Had I attempted to carry out this plan I am of the opinion that the native population would have overpowered me and saved the property for the enemy.

The last wagons, five in number, which left the town were escorted by Mexican volunteers and militia. While in camp near the Pueblo of Sandia the train was attacked by deserters from the militia and volunteers, when the escort was thrown in confusion, and the robber succeeded in carting off three wagons, with a portion of the mules. Much credit is due two wagon master Reilley for getting away with the remainder. Six wagons and teams which had been sent to the mountains for fuel on the morning of the first instant, and afterwards ordered to move by the way of Galisteo to Santa Fe, are missing and I have been informed they were attacked by Mexican robbers and the train carried off.

On March 2, 1862, the first Confederate soldiers rode into Old Town. Within an hour of arriving, a rider from the Union depot at Cubero reported that four Confederate sympathizers had secured supplies from the small Union outpost. Four days later, the badly needed supply wagons arrived.

When General Sibley arrived six days later, he established his headquarters in the adobe home of Raphael and Manuel Armijo. Along with a detachment of two hundred men, he would remain in Albuquerque while the remainder of his army would march north to attempt to capture Fort Union.

On April 8, Canby arrived in Albuquerque with his army of 860 regulars and 350 New Mexico volunteers. As he suspected, the Confederates had occupied the town. The first task before him was to assess the enemy's size and battle positions. He summoned James "Paddy" Graydon and instructed him to send his Spy Company to harass and threaten the Confederates. Paddy Graydon was a tough Irishman who had a reputation for being daring and reckless.

General Sibley, the commander of the Confederate army in New Mexico. *Library of Congress.*

In 1853, Graydon had immigrated to the United States to escape the potato famine in Ireland. He joined the U.S. Army and was posted to a dragoon unit in the Southwest. For the next five years, he fought the local native tribes, outlaws and other criminals from the Mexican border to Santa Fe. After an honorable discharge in 1858, he moved to Arizona and operated a saloon. He also tried his hand at raising crops and cattle ranching, but he missed the action of patrolling the frontier.

When the Civil War started, Graydon offered his services to Colonel Edward Canby if he would be permitted to recruit and lead his independent company of irregulars. The colonel agreed. In the village of Lemitar, Graydon recruited eighty-four of the toughest New Mexicans he could find. They enlisted for forty cents per day and provided their own horses and equipment. Graydon's Spy Company was born, and they were Canby's eyes and ears for the entire New Mexico campaign.

As the Spy Company approached the northern edge of Albuquerque, the Rebels opened fire with cannons and muskets. Graydon pulled his unit away as the Federal artillery joined the battle. The Battle of Albuquerque had begun.

Meanwhile, Captain Rafael Chacon and Major Thomas Duncan were sent to scout an area east of the city. Believing that he saw an opportunity, Chacon suggested that they attack the Confederate guns. However, Major Duncan reminded him of Canby's orders—they were only to observe and report back.

Suddenly, several Rebel six-pounder cannonballs came skipping across the ground; Duncan fell off his startled horse and was badly injured. He would be the only recorded casualty of the battle. What happened next is a matter of conjecture. One account states that during the Union cannonade, several residents from Albuquerque, including several of the town's most prominent women, somehow made their way to the Federal lines. They pleaded with Canby to stop the cannon fire, as it was damaging their homes and placing the noncombatants in grave peril. Another variant claims that the Confederates were not allowing the residents to escape in an attempt to use them as human shields. Canby's account of what transpired was recorded in his report to his commanders:

A Civil War mountain howitzer. *Library of Congress.*

I have the honor to report that in pursuance of the intention reported in my communication of the 31st ultimo my command (860 regulars and 350 volunteer troops) left Fort Craig on the first instant and arrived before Albuquerque on the afternoon of the 8th. I immediately made a demonstration upon the town, for the purpose of ascertaining its strength and the positions of the enemy's batteries. This demonstration was made by Captain Graydon's Spy company, supported by the regular cavalry, and developed the position of the batteries.

In the skirmish, Major Duncan, Third Cavalry, was seriously but it is hoped not fatally wounded. No other casualties were sustained. It was my wish to have made a junction if possible below the Confederate troops in order to cut off their retreat, but the state of our supplies and the inferiority of our Force rendered this inexpedient, and it was determined to continue the demonstration before Albuquerque in order that the Confederate forces might be withdrawn out from Santa Fe, and then by a night march place my command in a position from which the junction could be effected without danger or opposition to either column. Accordingly, the demonstrations against the town were continued, and during the night of the 9th and the succeeding day the command marched to this place. I am now in communication with the commander of the troops from Fort Union and can affect a junction at any point.

Regardless, Canby silenced his guns and withdrew to another position, approximately three miles to the southeast on the high ground that overlooked Albuquerque. Although he repositioned his artillery, the Union soldiers only used their muskets to snipe at the Confederate positions.

On the night of April 12, the Federals moved through Tijeras Canyon and Carnuel Pass. Both the local citizens and the Confederate soldiers watched the campfires of a thousand Union army soldiers as they burned brightly into the night. Worried, many residents wondered if the battle would resume the following morning. They heard the Union army musicians playing late into the evening. Eventually, the campfires died out, but unbeknownst to citizens or the Rebels, the Union army had left. Canby thought that Sibley's army would return to Albuquerque, so he ordered his soldiers to move south during the night quietly. The musicians were left behind for part of the evening to cover up the noise of their departure.

The following evening, they met up with Colonel Paul's army from Fort Union, which had arrived by marching through Galisteo. Canby's after-action report describes what happened next:

The plaza in 1880, looking south from the San Felipe Church. *Albuquerque Museum, Creative Commons (PA1990.13.43).*

> *I have the honor to report that a junction with Colonel Paul's command was affected at Tijeras on the evening of the 13th instant. I had in the meantime received information that the Confederate Force had left Albuquerque, moving down the river, and during the day and night of the 14th, the united*

THE WICKED ART OF WAR

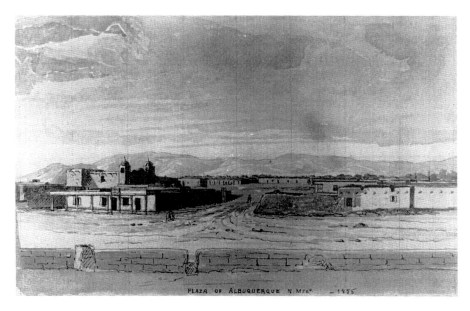

Old Town Albuquerque before the Civil War in 1855. *Emma Moya Collection, Center for Southwest Research, University Libraries, University of New Mexico.*

command was marched into Peralta, 36 miles distant, arriving there before the Confederates had any suspicion of the movement. On the morning of the 15th a mountain howitzer, at a train of seven wagons, loaded with supplies and escorted by a lieutenant and 30 men, were captured. In the conflict six of the Confederates were killed, three wounded, and 22 captured. To cover his movement Colonel Paul, which is column three companies of cavalry, under Captain Morris, Third Cavalry, had been detached and after completing it, receive permission to clear the bosque in front of Peralta of the enemies force that occupied it. After some sharp skirmishing, in which our loss was one killed and three wounded, this work was handsomely executed, and Bosque in front and rear of the town occupied by our troops.

The point occupied by the Confederate troops was known to be the strongest (except for Fort Union) in New Mexico, and as nearly all the men had been 24 and many of them 36 hours without food, no general attack was designed until after the approaches to the place had been thoroughly reconnoitered and the troops allowed time to obtain food and rest. This reconnaissance was made on the afternoon of the same day, the points and direction of attack selected, and the camp of the command advanced to a point nearer the town, and where the trains could be guarded by a smaller

number of men. *During the night the enemy abandoned his position and crossed to the right bank of the river, leaving his sick and wounded behind him, without attendance, without medicines and almost without food.*

The Battle of Albuquerque was over, but the battle for Peralta was about to begin.

The Modern-Day Controversy

Two plaques that are dedicated to the skirmish of Albuquerque are attached to the gazebo in the plaza of Old Town. The first plaque, which talks about the actual skirmish, reads:

While Confederate General H.H. Sibley was assembling the bulk of his army at Santa Fe, Union Colonel E.R.S. Canby moved 1200 men from Fort Craig to occupy Albuquerque "if it can be done without serious loss." Though outnumbered six to one, a small detachment of Confederates under Captain William P. Hardeman repulsed the attack and maintained possession of the town.

However, the plaque fails to mention that Colonel Edward Canby started the skirmish to test the strength of the Confederate forces and to expedite the retreat of the Rebels from Santa Fe. So the plaque is quite biased and not historically accurate in the account of what happened. The second plaque is dedicated to "buried Confederate veterans" and graces the opposite side of the gazebo. This plaque simply reads, "Confederate Soldiers who served in Gen Sibley's Brig with Major Trevanion T Teel were buried here when Conf Flag was flying over Old Albuquerque in April 1862."

Technically, this plaque is also inaccurate, as no Confederate soldiers have ever been discovered in Old Town. The question, then, is whether anyone has ever seriously looked. This is where things get interesting. The plaque was put up due to a statement made by Major Trevanion T. Teel years after the war was over. In an article in the *Albuquerque Journal* that was published on March 19, 1898, Teel recalled the aftermath of the battle as the Confederates prepared to retreat to Texas:

"We lost by battle and disease nearly one-half our Command, many died in Albuquerque," a rebel officer later recalled in an attempt to summarize

the New Mexico campaign. "We had pneumonia, smallpox, and measles. The deaths were so many there that the dead were buried in the night so that our loss could be kept from our own as well as the federal army."

Some historical sources cite as many as twenty-four Confederate soldiers died in Albuquerque before the withdrawal. Some passed away from wounds acquired at the Battle of Glorieta Pass and others from disease. If the burials were done with such secrecy, it is hard to determine exactly where those burials would be—but they are there.

The Price of Treason

The Confederates entered Albuquerque on the afternoon of March 2. A small crowd had gathered on the plaza and wildly cheered their arrival. The town of Albuquerque was in the hands of the Confederacy without having to fire a single musket. However, their enthusiasm was short-lived when they discovered that the Union troops had burned what had once been one of the largest depots in the territory before they retreated from the town. The capture of the station was critical to General Sibley's plans for sustaining his army and was vital to the overall success of the New Mexico campaign. However, the disappointment of the Confederates was also short-lived.

Shortly after the Texans entered Albuquerque, a Southern sympathizer named Richmond Gillespie rode into town with the encouraging news that the military post and depot at Cubero, sixty miles to the west, had been captured by a handful of Southern partisans. The depot had been commanded by Captain Francisco Aragon, a Union officer who had been dispatched to Cubero with his company of seventy-five militiamen to guard the outpost from any possible Confederate attack. Four days after leaving Albuquerque, the company arrived in Cubero. Aragon had difficulty controlling his men, as several soldiers deserted. When the disheartening news of the Confederate victory at Valverde reached the Union outpost, several other men deserted and left for their homes in Albuquerque.

Dr. Fenis Ewing Kavanaugh, a secessionist zealot, was able to persuade Aragon that the "Southern Confederacy was ruler of the territory and that his company must be dissolved." On the evening of March 2, he and three Confederate sympathizers gave Aragon ten minutes to disband his company and peaceably surrender the post or suffer the consequences. Aragon, who

was drunk at the time but still in command, finally agreed to surrender early the next morning. Twenty-five wagons were on their way to Albuquerque, filled with ordnance stores, medicines, sixty rifles and three thousand rounds of ammunition. Captain Alfred Thurmond of the Confederate army was quickly dispatched to Cubero with twenty-five men to secure the supplies and expedite them to Albuquerque.

William Kirk was the first Rebel to ride into the village of Albuquerque. Little did he suspect that in three weeks he would be severely wounded at the Battle of Glorieta Pass. During the painful mountainous retreat back to Albuquerque, his leg would be amputated.

The brigands who assisted the Confederacy were mostly zealots from the bar rooms, gambling dens and brothels of New Mexico. They were led by a man named John Phillips, a Santa Fe Hotel clerk and a gunslinger who traveled to Mesilla when the war began. Days before the Battle of Valverde, he enlisted in the Rebel army at Old Fort Thorn.

On the morning of March 8, 1862, Sibley, along with his staff, Manuel and Raphael Armijo and a few other Confederate sympathizers, rode triumphantly into Albuquerque and was greeted on the plaza by the raising of the Stars and Bars and a thirteen-cannon salute.

Perhaps Sibley's biggest coup was luring Manuel Armijo to the Confederate cause. He was one of the wealthiest merchants in the territory, and with the help of his older brother, Raphael, they were an enormous asset to the Confederacy. The Armijos were the nephews of the more famous Manuel Armijo, the three-time governor of New Mexico under Mexican rule. One Albuquerque resident, Franz Huning, would later testify that the Armijos were "deep in the plot of the invasion."

The Armijos offered Sibley the use of their spacious adobe home for his headquarters. Located just off the plaza, it provided a perfect location for Sibley to plan the remainder of the invasion of New Mexico. Sibley wrote to the Confederate headquarters at Richmond that the Armijos "came forward boldly and protested their sympathy with our cause, placing their stores, containing goods amounting to $200,000 at the disposal of the troops and that the brothers were undoubtedly the wealthiest and most respected native merchants in New Mexico."

Sibley gave Raphael Armijo a draft redeemable in gold for the $200,000 in goods that the brothers provided the Rebel army, but the Confederate government in Richmond never honored the obligation.

After the Confederate loss at the Battle of Glorieta, it became necessary to evacuate the territory. The Armijo brothers were forced to abandon

Casa Armijo in 1940. *Library of Congress.*

luxurious homes, as well as full storehouses, to share in the fate of the Confederacy. Although they fled with Sibley's Confederate army, Manuel's only son, Diego, remained behind in Albuquerque to watch over the family's mercantile interests. In the spring of 1863, he was charged with aiding and abetting the Texan Rebels and was thrown in jail. Later, on November 1, 1863, he signed a loyalty oath to the United States in hope of avoiding prosecution.

After the Confederates had made their way back to San Antonio in the summer of 1862, virtually all of the New Mexicans who had cooperated with the Confederacy were rounded up and tried for treason. Those who failed to appear in court had their property confiscated. The Armijo brothers in particular were to pay a high price for their disloyalty.

They had extensive landholdings for storing crops and cattle. From the Sitio de Navajo land grant, they owned 100,000 acres, which they had purchased in 1850. The pride and joy of the Armijo family were their ranches, the largest of which they named Los Lillos. The 1860 census shows that the brothers claimed identical declarations of assets, including twenty-two servants.

When U.S. Marshal Abraham Cutler began seizing the property of Southern sympathizers, he also brought federal lawsuits against their properties, including Los Lillos. Manuel fled to Richmond, Virginia, while Raphael set out for San Antonio, Texas. Anger came from every direction, including members of their own family. Their cousins Cristobal and Ambrosio Armijo posted securities for the plaintiffs in two cases. Salvador Armijo readily agreed to testify for the U.S. government at the treason trials.

The Union government took action against Southern sympathizers under an act of Congress permitting confiscation and the sale of real and personal property of those declared guilty of disloyalty. Besides losing approximately $200,000 to the Confederates, the Armijo brothers also lost their stores, flour mill and ranches, which had an estimated value of $400,000. The Union government also confiscated $38,964.40 in United States money, and other properties in Albuquerque and Mesilla were condemned and ordered sold by decree of the United States Court in Albuquerque on June 14, 1864.

Raphael and Manuel Armijo returned home to Albuquerque and the Territory of New Mexico in June 1866. Both had taken the oath of allegiance to the United States two months earlier. Raphael reestablished his residence in Dona Ana County, and Manuel eventually returned to Albuquerque.

Within the following year, Manuel was once again involved in several lawsuits to recover the properties and wealth of his family. When Manuel died in 1881, Raphael took over the management of businesses in Albuquerque. By now, the family was divided. Raphael's nephew Francisco Armijo Otero and his cousin Perfecto Armijo were sued by Raphael because they had conspired to sell properties that he claimed were owned by Los Lillos. He lost the case. In the end, Raphael remained a Southern sympathizer and preferred to live near the Mexican border in Las Cruces, New Mexico.

On April 7, 1862, Colonel Miguel Pino arrested Captain Aragon at Los Pinos and sent him to General Canby at Fort Craig for punishment. Kavanaugh, along with his accomplices, was eventually caught and indicted for treason.

Another individual in Albuquerque, Blas Lucero, was also a Confederate sympathizer and welcomed the Rebels into town on March 4, 1862. When the Confederates found themselves on the losing side of the war, Lucero fled with them to the safety of the Mesilla Valley. Later that summer, when the Confederates withdrew to San Antonio, Lucero crossed the Rio Grande and hid with secessionist sympathizers in El Paso del Norte. In December 1862, General James Carleton issued orders that granted Blas Lucero a passport to return to the New Mexico Territory. However, the passport contained a

The Wicked Art of War

Casa Armijo, now the La Placita Restaurant in Old Town. *Library of Congress.*

special provision. It was granted with the understanding that Lucero had been indicted for treason and that he would still be liable and subject to arrest and confinement when he arrived at his home in Bernalillo. One month later, he arrived in Albuquerque and was quickly arrested and charged with "aiding and abetting the enemy." After a short trial, the Federal courts seized his home and three tracts of land, plus personal property that was valued at ninety-six dollars. In May 1864, it was all sold at public auction in the Albuquerque Plaza.

José Maria Chavez, a priest at Peralta, was also found guilty of treason and lost his house, all of his land and his farm in February 1863. The *Rio Abajo Weekly Press* was quoted as calling him "more like the devil than a minister of the Gospel."

In the aftermath of the Confederate invasion, the trials were often long and drawn out. If was a different story when the legal actions were taken by courts-martial and the military commissions that were convened by the army. These were often very immediate and very consequential. One of the most controversial cases that came before the military commission

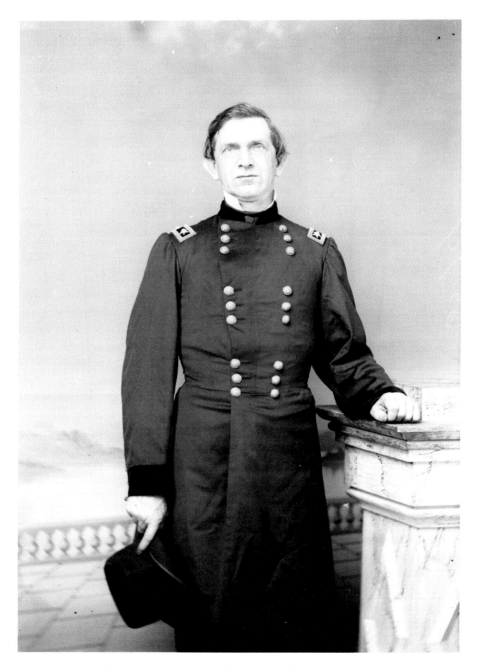
Colonel Edward Canby, the commander of Fort Craig. *Library of Congress.*

was that of James Holmes, the editor of the *Santa Fe Republican* and acting territorial secretary.

Holmes was arrested in Santa Fe by the city marshal under the orders of General Canby. The trouble started when Holmes published an article in his newspaper on July 5, 1862, called "Fort Building in New Mexico." The lengthy article started off by praising the construction and modifications of the second Fort Union. Built at a cost of $70,000, this "second" fort was upgraded with the latest in strategic military design that was available at the time. Holmes wrote, "The angles of the star-shaped fort skillfully placed and the interior arrangements made the fortification a truly beautiful structure that would make any West Point engineer proud."

Holmes continued, describing a "defensive test of the fort" executed by Captain Peter Plympton. Plympton suspected that the fort had been constructed too close to the bluffs and that it might be within the range of any artillery that was fired from the buffs. To test his theory, he placed a six-pound gun at the base of the hills and a twelve-pound howitzer at the crest and fired them in the direction of the fort. Both weapons were "fired at least three times" and effortlessly hurled shells into the fort.

He then fired a six-pounder from the western bastion of the fort toward the hills to determine if it was possible to reach the previous positions from which he had fired. "With the greatest elevation that could be given it," he reported, "the ball only reached about midway of the hills from which the howitzer was fired." As far as Holmes was concerned, Plympton's experiment had proved that the fort was worthless, and he had no problem publishing what he believed.

Initially, he was arrested for refusing to give Canby the sources of his information. Although he would later admit that several individuals had provided him with information for the controversial article, he chose to remain silent. Sometime after Canby appointed the members of the court that would hear the case, the charges were elevated. Holmes would be charged with "giving intelligence to the enemy, providing Aid and comfort to the enemy, and for disobeying orders." Additionally, they charged that he sought to weaken the "strength and value of the entrenchments at Fort Union" and "impair the confidence of the Union troops and the people of New Mexico," all of which invited "attack by the enemy."

With little discussion, the court found Holmes guilty, and he was sentenced to three years at hard labor or hard labor for the duration of the war. While the commission stated that Holmes's article did reveal the vulnerability of Fort Union, it also agreed that it was an act of indiscretion rather than

The "star fort design" of Fort Union. *Library of Congress.*

premeditated guilt. As a result, the commission recommended clemency. Reluctantly, Canby decided that Holmes had not been disloyal to the Union. He was released shortly after the trial.

Many of the family heirs of the Southern sympathizers whose property and assets were confiscated in the "treason trials" tried to overturn the indictments and consequences of the trials. While the Federal Forfeiture Act of 1862 was being written, President Lincoln insisted that the forfeiture took only the life estate of the trader. This meant that the property that was left to the heirs would be exempt. Unfortunately for them, that "insistence" did not make its way sufficiently into the bill for a judge to rule in their favor. In America, there is no concession for treason.

Lost Cannons and Legends

There have long been legends about the cannons and other treasures buried by the Confederates while they were in New Mexico. Some stories are true and others are not. The search for the relics has created controversy, intrigue and even a scam or two. To understand the mysteries behind the Civil War cannons, we must first quickly recap what happened in 1862 during the New Mexico campaign.

For thirty-six days in 1862, Albuquerque became the Confederate capital of New Mexico. After a bloody battle, a portion of the Fourth Regiment of Texas Mounted Volunteers under the command of General H.H. Sibley failed to take Fort Craig, south of Socorro. In need of supplies, the exhausted troops pushed on to Albuquerque. Union soldiers, meanwhile, had moved everything possible from their Albuquerque post, burned everything remaining and retreated north under Captain Herbert M. Enos.

The Confederates entered Albuquerque on March 7. They held a ceremony to claim the village and the state of New Mexico for the Confederacy. After firing a thirteen-cannon salute, they raised their flag on Old Town Plaza. Albuquerque was now under its fourth flag in 156 years.

For two weeks, the Rebels foraged for food in the Sandia Mountains and stocked up on captured supplies. Then they marched north to engage the Union forces that were stationed at Fort Union. The Union met them at a place called Glorieta Pass, just north of Santa Fe. While the Texans fought a decisive battle, a detachment of Colorado Volunteers outflanked them and destroyed the entire Confederate supply train. The Confederates had no other option but to retreat to Texas.

On April 10, there was a skirmish when the Confederate forces of two hundred men were engaged by the Union army under General Canby. They exchanged artillery fire with Union forces until the Yankees had withdrawn. With the enemy moving down from the north and marshaling in the east, General Sibley decided to gather his men and leave for El Paso. General Sibley made the decision to abandon some of his artillery in Albuquerque. The Rebels needed the carriages to haul the few supplies they had left.

Late on Friday night, April 11, the Texans secretly dug a hole in a corral five hundred yards northeast of the Albuquerque Plaza. Eight cannons were placed into the soil and thoroughly covered. This was to ensure that the cannons would not fall into Union hands. The Confederates left Albuquerque the following evening, and the town was once again in Union hands.

The original cannons in the plaza before they were moved to the Albuquerque Museum.
Emma Moya Collection, Center for Southwest Research, University Libraries, University of New Mexico.

After the war, in 1889, a Civil War veteran named John Crawford met up with Trevanion Teel, who had served as a captain of light artillery with the Confederate army during the invasion of New Mexico. During their conversation, Crawford mentioned that he wanted some Civil War relics to take to the New Era Exposition, which was going to be held in St. Joseph, Missouri. Teel, having been one of the officers who helped bury the cannons in Albuquerque, told Crawford of the abandoned ordnance and offered his assistance. On August 17, 1889, he met Crawford and Henry Whiting, another Union veteran, in Old Town Albuquerque.

After getting his bearings, Teel led the two men to a field about five hundred feet northeast of the San Felipe de Neri Church. He pointed to a garden that in 1862 had been a walled corral. They entered the garden and walked back to a chile patch. Teel pointed to the chile and told them, "Dig here, and you will find them."

The two Union veterans located the owner of the property, a man named Sofre Alexander. They asked him for permission to dig in the chile patch, but Sofre refused. They even offered him $100 to offset the cost of

any damages from the digging. Again the landowner refused. Undaunted, veterans went to see Judge William Lee, another Union veteran, who then blocked Sofre's request for a preliminary injunction. The judge was also curious if the Rebels had buried any cannons in Albuquerque.

On August 19, the excavation began. Later that afternoon, the cannons were found two feet north of the spot where Teel had pointed. They were found at a depth of three feet, and when they were first uncovered, the cannons gleamed in the sunlight.

Shortly after the cannons were excavated, Elias Stover, a former governor of the state of Kansas, wrote to Teel at his home in El Paso, Texas. He asked Teel for any additional information about the cannons or the New Mexican campaign that he could remember. Teel wrote down what he could recall and sent the letter to Mr. Stover. The letter, in its entirety, was published in the *Albuquerque Daily Citizen* on August 26, 1887:

> *Your letter of the 20th instant is at hand, and in reply to the questions, would say:*
>
> *I do not now recollect whether there were more cannons buried at the place you found the eight: Nor do I remember whether larger guns were buried in that place or not. There are a number still unearthed in New Mexico, some I think I could find, others I do not believe I could.*
>
> *The pieces buried in the mountains opposite Fort Craig I think could be found; they are large pieces, field guns, 6s and 12s brass. Those near Santa Fe I do not believe I would be able to locate. My command entered Santa Fe at night, and while we were there the days were cloudy, and much snow fell, hence I did not notice the points of the compass. The pieces were interred in the night, I think about a mile north of the government corral, in an open place, such is my recollection. I regret exceedingly that I cannot point out the exact place.*
>
> *You ask me to give you a short history of the transaction. So many years have passed since that eventful period that much of the history has passed beyond my recollection. Ordinarily, I would have paid more attention to the surroundings, but at that time there was hardly any thought in the army but one to "get out of the country."*
>
> *We were without food, clothing, and ammunitions of war, but little transportation, and between two columns of Federal troops, General Canby below us, Colonel Slough above us, each with an equal number of troops, and twice as many as we could muster. So you see but that little time was left for observation at that city.*

All the guns we had were captured from the United States forces at one time or another, after hostilities had commenced, and at this day it would be impossible for me to state to you when and where they were captured; but this I can say, that the Valverde battery captured at the battle of that name was not left in New Mexico, but was taken by us to Louisiana, and at the close of the war was at Red River in that state.

As to the officers of my command who assisted in hiding the guns in Albuquerque, Capt. J.W. Bennett (dead), Capt. Maginnis (dead), Lt. McFarland (dead), Lt. Bradford (dead) and Lt. Phil Fulcroid; the others I do not recollect; in all probability there may have been some noncommissioned officers and soldiers of my command also of the party, and there may have been some other officers of the army present.

I do not think there were any large guns buried at Albuquerque. I have been taxing my memory about the matter, and I have concluded that there were no large guns left there.

We lost by battle and disease nearly one-half our command; many died in Albuquerque. We had pneumonia, smallpox, and measles. The deaths were so many there that the dead were buried in the night so that our loss could be kept from our own as well as the Federal army.

We left Albuquerque with a day and a half rations, three rounds of ammunitions to the man, and had about quarter transportation for the long trip ahead.

When we left Puerco River, we had nothing to eat; traveled all night, camped a short time about daybreak, rested our animals an hour or two, then started our March. I lost 90 head of animals; this was the reason we left the pieces in the mountains. I left my ambulance by the roadside, having taken my four horses to hitch to the guns. Every horse and mule that was able to work were taken and hitched to the guns. The next night we camped without food or fuel, and the weather was intensely cold.

The next morning about 8 o'clock we found water at Alamosa Canyon. We rested most of the day, then took up our line of march for Fort Thorn. Our cannon were hauled up the mountainside by the troops. It was an almost impossible undertaking, but we succeeded.

That day we met General Steele with provisions, dried beef, some coffee, and a little flour; it makes my mouth water now to think how I relished that poor diet.

My heart bleeds when I think of the poor wounded and sick soldiers we left in the snow by the roadside; some with measles, others with pneumonia or smallpox; some were wounded. Captain Kirk was wounded at Glorieta,

had his leg amputated while on the road through the mountains, a wagon for the hospital; with all of this he recovered and lived for many years afterwards.

All these details, governor, are not pleasant reminisces. I pray your petition to the Secretary of War will be granted and that your city may be the depository of the guns which have lain so long in her soil.

God bless our United, prosperous and happy country, and may there never be another fratricidal war in this glorious land.

Fraternally yours,
T.T. Teel

After lots of discussion, arguments and Congressional pressure, the United States government gave four of the cannons to the State of Colorado and the remaining four to New Mexico. The four Colorado guns are accounted for and are catalogued in the holdings of the Colorado State Museum. Of the four guns given to New Mexico, two are missing. The other two were displayed in the plaza in Old Town until 1983, when they were moved to the Museum of Albuquerque for permanent display.

The sand hills near Socorro, where one of the lost cannons was discovered. *Library of Congress.*

So, where are the two missing cannons? Some historians suggested that they were moved to Santa Fe, where they were donated to a World War II scrap drive. The October 15, 1942 issue of the *Santa Fe New Mexican* noted:

> *The brace of Plaza Cannon, the Civil War monsters that have pointed inhospitably at generations of Santa Feans, are going to fire again, this time in a new form and at new enemies.*
>
> *The city council last night voted to give the 700-pound barrels to war furnaces a scrap, and at the same time instructed the building engineer to dismantle the old sewage disposal plant west of town and deliver the metal to the cities scrap pile.*

The article presents a problem because it refers to the cannons as "monsters" weighing 700 pounds. The missing cannons from Albuquerque were twelve-pounder mountain howitzers. They are the smallest of the Civil War–era cannons, measuring about thirty-three inches in length and only weighing about 220 pounds, far from the "monsters" described in the article. This makes it very improbable that the cannons in Santa Fe were the missing guns of Albuquerque. So, the question remains: where are the two missing cannons?

As for the other buried guns, several clues lie in the Civil War journal of A.B. Peticolas, an officer who served in Sibley's Confederate army. In his journal, he states that after leaving La Jencia, the Texans continued across the plains. They camped at Ojo del Pueblo, which is near present-day Magdalena. The effort that it took to haul the artillery along the sand dunes and dangerous mountain trails was cumbersome, as Peticolas recorded in his journal:

> *Sunday, 20 April 1862. Some talk of spiking the artillery and leaving it; 2nd Regt. and Green have gotten tired in one day of helping their battery along, but it was not done. Scurry undertakes to take them through and will not consent to leave behind us the only trophies we have been able to keep of our victories.*

From his diary entry, it is very apparent that the McRae cannons, the "trophies," were still with Scurry's command and Teel's Battery assigned to Lieutenant Colonel Green. This also seemingly proves that none of McRae's five cannons were buried in Albuquerque, as some historians have believed.

From Magdalena, the Texans marched along the western edge of the mountains to Texas Springs. Then they turned south along the San Mateo mountain range. On April 21, Peticolas wrote, "[P]assed in sight of Ft. Craig....Climbed a high steep hill, dragging up the eight heavy guns." Historians have struggled with this entry for years. If the Texans had nine cannons on April 19, what happened to one of them by April 21?

The answer was that it had been buried near the town of Socorro. In the early 1950s, it was found on La Jencia Ranch by a ranch hand who was curious about an "old well casing" that was sticking up out of the ground in an arroyo. When he got closer, he discovered that it was a cannon. The artillery piece passed from person to person over the years before it landed in the hands of a Socorro history buff named Herbert Ross. In 1962, it was displayed in the Socorro plaza as part of the 100th anniversary of the Battle of Valverde. An article published by the *Albuquerque Journal* on February 10 gave a brief description: "Of special interest will be an exhibit on the Plaza of little John and lacrosse missiles from White Sands Missile Range displayed alongside a Union Army Civil War Cannon which was captured by the victorious Confederate Army at Valverde, contrasting military weapon development expanding a hundred years."

Many of the residents of Socorro remember the cannon that was on Abeyta Street in front of the Ross home. The gun mysteriously disappeared in the late 1970s. It was stolen by an Albuquerque man named Howard Elam. Elam, who had recently been released from prison for stealing more than four thousand historical documents from the UNM Library, used the stolen cannon as a mold to make fake replicas. Using the bogus cannons, he would then scam investors into financing expeditions to search for the missing Confederate cannons.

After several of Elam's former clients had made formal complaints about his business, the attorney general of New Mexico launched an investigation. At one point, Elam even sold a bogus cannon to the U.S. Army. The *Farmington Daily Times* reported the story in 1986:

Arvil Howard Elam. *From the* Albuquerque Journal.

The US Army paid about $3,000 to an Albuquerque man in the 1970s for bogus Confederate Civil War memorabilia, officials said Saturday.

Roger Durham, the curator at the Army Museum at Fort Bliss, Texas, said he thought the artifacts were fake last September but didn't act on his suspicion until the New Mexico Attorney General's office contacted him as part of its investigation into Arvil Howard Elam.

"The things didn't seem Dixie to me," Durham said.

State and federal agents have confiscated truckloads of artifacts and more than 150 skulls from Elam's home in Northeast Albuquerque. The searches were conducted last week and late last month because authorities suspected the house contained artifacts stolen from government lands for burial sites.

Elam was convicted of nine counts of fraud and one count of attempted tax evasion on December 19, 1987. During the trial, he was found guilty of defrauding five men by taking them on expeditions that turned up fake treasures, charging them for subsequent expeditions and for bogus treasures, which included gold bars and Confederate relics. One trial witness testified that the men lost more than $82,500 in cash and valuables. Elam was sentenced to fifteen years in prison for his treasure schemes.

For the adventurous and curious, there are still buried treasures out there to seek. The cannons buried near Santa Fe have never been found. Two additional cannons that were once in Albuquerque may exist as well. And where is the cannon that was stolen by Arvil Howard Elam?

Part V

ATOMIC WICKEDNESS

Albuquerque has had a significant role in the development of the atomic bomb, some of which played out on the national stage.

Doomsday in Albuquerque

In 1986, a local newspaper obtained documents that had been declassified through the Freedom of Information Act. The reports told of a mishap that involved the accidental release of a Mk-17 hydrogen bomb near Albuquerque on May 2, 1951. As the aircrew prepared to land the B-36 bomber at Kirtland Air Force Base, the ten-megaton bomb, the largest nuclear weapon the United States had at that time, slipped from its harness and crashed through the plane's bomb bay doors. It fell 1,700 feet before hitting the desert floor and exploding. The non-nuclear explosion killed a cow, but no people were injured.

Richard "Dick" Meyer, a retired lieutenant colonel, contacted the *El Paso Times* after reading a story about the bomb in the *Albuquerque Journal*. Meyer was piloting a B-36 bomber on a routine flight from Biggs Air Force Base in El Paso to Kirtland Air Force Base in Albuquerque. The *El Paso Times* also interviewed Jack Williams, as well as Jack Resen. Williams was a first lieutenant who was serving as the flight engineer when the incident happened. Resen, who was a major assigned as an electronic officer for the

Ninety-Fifth Bomb Wing, was simply along for the ride. The *Santa Fe New Mexican* published the interview on August 29, 1986:

> *Meyer recalled of the day the bomb fell: "The scanner, a crew member stationed about halfway between the wings and the tail, could see what happened out of his bubble.*
>
> *"Simultaneously, he called 'bombs away,' and the plane lost upward about 1,000 feet lost so much weight at once," Meyer said.*
>
> *"And someone yelled, oh* [expletive].*" It might have been me.*
>
> *Williams said they heard a "dull thud" when the bomb hit.*
>
> *And Meyer said, "we swung around and saw the plume of it, more dust cloud than anything."*
>
> *Resen said he was near the bomb bay when the young Lieutenant who had been preparing the bomb for landing "came charging out of the bomb bay saying 'I didn't touch anything. I didn't touch anything.'" It really made me laugh.*

Meyer and Williams, who were with the Ninety-Fifth Bomb Squadron at the time, said they were flying the 42,500-pound bomb to Kirtland for routine maintenance when the accident happened. Meyer said the crew was following the standard procedures when a nuclear weapon was loaded aboard an aircraft:

> *"A man goes back and inserts the manual locking pin* [a safety pin that locks the bomb in] *after you take off," Meyer said.*
>
> *"Then, when you get where you're going, in the traffic pattern for a landing, a man crawls back into the bomb bay and takes out the pin, in case you wanted to salvo* [release] *the bomb due to a problem with the airplane."*

The major issue was whether or not the man who pulled the pin had leaned against the cable that would release the bomb. "He said he didn't"; he said he had just pulled the pin. He had one arm around a girder and the other pushing back from the bomb. "It just drifted right straight through the bomb bay doors. The latches were still latched."

The bomb, which was twenty-four feet long and five feet in diameter, had three parachutes that were designed to deploy out the rear to stabilize its fall, said Meyer. "The parachutes were starting to deploy when the bomb hit the ground….A light plane was in the area. It liked to have blown him out of the sky from the explosion."

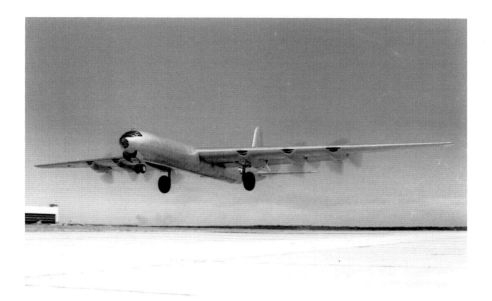

A B-36 bomber, the type of aircraft that inadvertently dropped the bomb. *Library of Congress.*

During the entire episode, there never was any danger of a nuclear explosion. "We were not carrying all of the essential materials needed to arm it for dropping as a weapon," Meyer said. "Only in a wartime configuration would you have everything there." He said the bomb was the first hydrogen bomb built to be carried by aircraft.

One researcher, in an interview by the *Albuquerque Journal*, claimed that the bomb was possibly the most powerful weapon that the United States had in its arsenal at that time. It is entirely possible that the yield of that weapon could have been as much as ten megatons—625 times the total power of the atomic bomb that was dropped on Hiroshima in 1945. The article continued:

> Meyer and Williams declined to say more about the bomb because they stated that they don't know what might still be classified about it. But Meyer said the first hydrogen weapon used supercooled hydrogen liquid and was exploded on a tower, because it was too large for a plane.
>
> He said the B-36 that day was relatively light, carrying perhaps only about one-third of its 320,000-pound potential fuel load, due to the short flight.

"That made it climb about 1,000 feet 5 seconds after the bomb fell," Williams said.

"The men stated that they landed at Kirtland without further incident, then spent all the next week being questioned by investigators, who interviewed each crew member separately and had them write down their stories," Williams said.

He and Meyer said the investigation probably took so little time because the bomb had fallen at the place the experts on nuclear weapons are located.

They agreed that if a bomb had to fall, it fell at the right place. Meyer said he had heard that in addition to the government having to pay a rancher for the dead cow, there was also a hefty bill for all the land that was blown up. The U.S. Air Force also had to clean up all the debris, and the surrounding dirt was hauled away. Williams and Meyer said they were not allowed to speak about the accident at the time.

Meyer stated that two aircrews were on board, including three pilots, because other airmen may have been heading elsewhere or just getting in needed flying time. Another man who said he was a crew member aboard the bomber told the Associated Press that he didn't see the bomb actually fall but that he knew that it had when the aircraft suddenly moved upward.

George Houston, a retired air force radio operator, said it was one of those things that is terrifying at the time but "funny afterward." He compared the incident to the final scene from the movie *Dr. Strangelove*, an early 1960s film in which Slim Pickens as an air force pilot rides a nuclear bomb down on the Soviet Union after dislodging it from the bomb bay.

The bomb exploded on Mesa del Sol, about three miles southeast of the Albuquerque Airport and about three miles west of the Isleta Amphitheater. Although the plutonium pits were stored separately on the plane, the accident still spread radioactive material over a wide area. The air force secretly cleaned up the site, although fragments of the bomb, some of which are still slightly radioactive, can be found in the vicinity. Ironically, two months after the accidental drop of the hydrogen bomb, the city of Albuquerque participated in Operation Alert 1957. The make-believe warfare was part of the New Mexico civil defense organization's participation in a nationwide test of the country's preparedness facilities. The *Albuquerque Journal* published the results of the training drill on July 13 with the headline "Powerful H-Bomb 'Nearly Destroys' City; 25,200 Die."

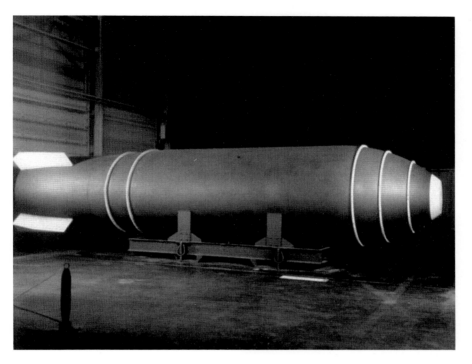

The Mk-17 hydrogen bomb. *Library of Congress.*

> *The City of Albuquerque was "almost destroyed" and 25,200 persons "killed" when enemy bombers drop a 5 Megaton hydrogen bomb in the middle of the East–West runway at Kirtland Friday.*
>
> *The Bombs were dropped by a fleet of enemy planes which streaked over the polar ice cap and spread out to rain destruction over most of the United States.*
>
> *Nearly all of Albuquerque's "fatalities" or persons who refused to leave the city when they order to evacuate came at 10:10 a.m. Friday. Some 142,800 persons "left" Albuquerque safely ahead of the appearance of the bombers. About 7,500 persons were injured, 5000 of them seriously.*
>
> *Civil defense officials reported Friday night that radiological studies show that it will be 10 years before the city can be occupied unless all rubble is turned over by bulldozers and buried.*

The article then went on to describe the damage that a ten-megaton bomb would have caused if it were detonated in the city:

The "bomb" which hit Albuquerque had the power of 5,000,000 tons of TNT. It totally destroyed an area bounded by Copper on the north, the Person Station power plant in the south, Utah on the east and Elm on the west.

Heavy damage occurred from a radius of 3.1 miles from "ground zero," Hannett on the North, Eubank on the east, the Rio Grande on the west, and unoccupied land on the south.

The C-ring or medium damage area, had a radius of 6.2 miles, the city limits on the north and east and the Cutter Carr airport on the west.

The moral of the story is that if the air force says that you need to evacuate, you should endeavor to do it!

Trinity and the Soviet Spy Ring

Born in New York City on May 12, 1918, Julius Rosenberg was the son of a Russian immigrant. In his youth, he pondered the possibility of becoming a rabbi, but as his interest in politics grew, he abandoned religion over the radical politics of the Young Communist League. After high school, Julius attended City College, where he studied electrical engineering. This is where he met Morton Sobell, an acquaintance who would later become involved in the Soviet spy ring in New Mexico with Julius.

In 1935, Julius met a clerk named Ethel Greenglass while at a union party. They had several things in common, as they were both members of the Communist Party. The two struck up a conversation and started to become acquainted. However, Ethel was scheduled that night to sing before the crowd. She was nervous and asked Julius if they could retire to a private room where she could practice. After that, they were inseparable. They married in 1939.

During World War II, Julius Rosenberg got a job working for the U.S. Signal Corps. He was laid off in 1945 when his affiliation with the Communist Party was discovered. However, his life was about to change drastically when he met a former spymaster for the People's Commissariat for Internal Affairs (NKVD), Semyon Semyonov.

Semyonov recruited Rosenberg on Labor Day in 1942 after being introduced to Rosenberg by Bernard Schuster, another acquaintance of Rosenberg's from the Communist Party in the United States. Over the next

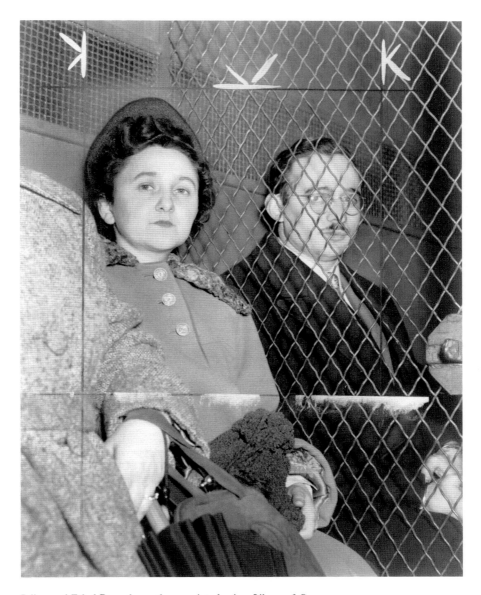

Julius and Ethel Rosenberg, the convicted spies. *Library of Congress.*

two years, Rosenberg provided a multitude of classified documents and other items to the Soviets. In one of the more infamous instances, he gave Semyonov a functioning proximity fuse. An upgraded model of this fuse was used to shoot down Gary Powers's U-2 spy plane in 1960.

In 1944, Semyonov was recalled to Moscow, and his "handler" duties were taken over by Alexander Feklisov. Under Feklisov's guidance, Rosenberg began recruiting other spies in New Mexico. These new recruits included Morton Sobell, Alfred Sarant, Joel Barr, William Perl and, eventually, David Greenglass, his brother-in-law. Greenglass was working on the Manhattan Project, a top-secret research project at the Los Alamos National Laboratory to help develop the first atomic bomb. With this new contact, Rosenberg was able to obtain classified information on the bomb that he passed on to Feklisov.

Rosenberg also succeeded in recruiting Russell McNutt, an engineer who worked at the Oak Ridge National Laboratory. McNutt provided Rosenberg with classified information that detailed the processes for manufacturing weapons-grade uranium.

After seven years, the spy ring was finally infiltrated when decoded Soviet messages implicated a man named Klaus Fuchs. Fuchs, a theoretical physicist, had provided the USSR with classified information during the war. After he had been apprehended, he revealed the name of his carrier, a man named Harry Gold. Gold, in turn, implicated David Greenglass.

The Federal Bureau of Investigation (FBI) arrested Greenglass in June 1950. He confessed to espionage and told the authorities that Julius recruited him while he was visiting Albuquerque, New Mexico, in 1944.

During his interrogation, Greenglass did not mention his sister's involvement with the spy ring. However, he later changed his story and said that she had participated, claiming that he saw her transcribing the stolen secrets on a portable typewriter at her apartment home in New York in 1945. Additionally, he testified that he had given Julius Rosenberg research data obtained through his job at Los Alamos.

Julius Rosenberg was arrested on July 17, 1950, and taken into custody. His wife was apprehended a few weeks later. Another member of the spy ring, Morton Sobell, fled to Mexico City. One month later, he was arrested by the Mexican police for bank robbery and extradited to the United States. Sobell was charged and tried with the Rosenbergs for conspiracy to commit espionage.

The mug shot of David Greenglass. *Library of Congress.*

Atomic Wickedness

The Rosenbergs' trial began eight months later in March. Both Julius and his wife pleaded not guilty to the charges and were adamant about their innocence. The trial was fueled by anti-communist sentiments, partially due to the involvement of the United States in the Korean War. The publicity of the trial was inflamed by the news from the front in Korea. Julius and Ethel were eventually convicted of conspiracy to commit espionage. They were given the death penalty in early April 1951.

The couple's lawyers immediately started a series of appeals that delayed their execution for more than two years. During that time, they requested clemency from two U.S. presidents, Truman and Eisenhower. However, both leaders refused to issue a pardon.

On the night of June 19, 1953, the Rosenbergs were executed at Sing Sing Prison in Ossining, New York. Their execution was publicized in great detail by the United Press:

> *SING SING PRISON, N.Y., June 20, 1953 (UP)*—*The United States had exacted full payment today from Julius and Ethel Rosenberg for the atomic age betrayal of their country.*
>
> *Their lips defiantly sealed to the end, the husband and wife spy team went to their death in Sing Sing's electric chair shortly before sundown ushered in the Jewish Sabbath last night.*
>
> *The Government had hoped to the last that they would talk.*
>
> *Executioner Joseph Francel sent the electrical charges through their bodies. Julius, the weaker, went first. He died with a grotesque smile on his lips. A wisp of smoke curled toward the ceiling as the current charged through Mrs. Rosenberg.*
>
> *It took three shocks of 2,000 volts each to electrocute Mr. Rosenberg. Four jolts swept through Mrs. Rosenberg, and still, she was not dead. A fifth was ordered.*
>
> *Thus was sealed the secrets of a Soviet spy ring which many experts fear may still be operating in this country. The Rosenbergs refused to the end to trade the secrets for their lives. The Associated Press ran several stories which provided the details of the execution.*
>
> *The husband and wife were executed against a backdrop of worldwide agitation unequaled since the Sacco-Vanzetti case of the 1920s. Inflamed by Communist propaganda, the demonstrations reached such fever pitch in Paris that a shooting broke out and one man was wounded. The White House in Washington was virtually besieged.*

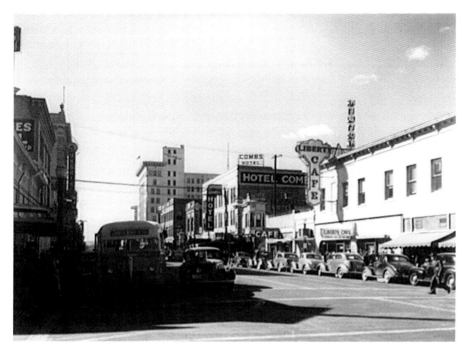

Central Street in downtown Albuquerque in the 1940s. The Hilton Hotel, in the distance, was a rendezvous spot for the spy ring. *Library of Congress.*

The Rosenbergs were the first American civilians to die for spying. They were accused of sending a rough sketch of the atomic bomb to Russia. "Plain, deliberate, contemplated murder is dwarfed in magnitude by comparison with the crime you have committed," Judge Irving Kaufman said in sentencing them to death on April 5, 1951. "Millions...may pay the price of your treason," he said. Three times the couple had been spared.

> *Relatives claimed the bodies of the thirty-five-year-old electrical engineer and his plump, thirty-seven-year-old wife, and they were expected to leave here by hearse around midmorning for a still unannounced burial ground.*
>
> *Julius Rosenberg, a look of defiance on his face, his eyes staring straight ahead and displaying no emotion, was the first to die. He was placed in the chair at 8:04 p.m. and was pronounced dead at 8:06.*
>
> *Ethel, attired in a dark green figure print dress, came calmly, stoically, into the death chamber only two minutes after her husband's body had been taken into an autopsy room less than 20 feet away.*

She was strapped in the chair. The cathode element, soaked in a saline solution and resembling a football helmet, was fitted to her head.

Then Francel, an electrician whose sideline is acting as executioner in prisons in five states threw the switch. That was at 8:11¼. Four and one-half minutes and after four more shocks Ethel Rosenberg was dead.

Doctors H.W. Kipp and George McCracken applied their stethoscopes to her chest.

Kipp turned to the warden and said: "I pronounce this woman dead."

Before their death, their defense counsel, Emanuel Bloch had waged a bitter legal battle that went five times to the U.S. Supreme Court. Twice, Bloch asked the White House for presidential clemency.

Ten official witnesses, six prison guards, and Francel were in 40 by 40-foot death chamber to see the Rosenbergs die. The group included three newspapermen, Relman Morin of the Associated Press, Bob Considine of International News Service, and this writer. The three, immediately after the executions briefed 35 other newspapermen in the prison's administration building.

The other official witnesses were U.S. Marshal William A. Carroll; Warden Wilfred L. Denno; Rabbi Irving Koslowe of Mamaroneck, N.Y.; Thomas M. Farley, Carroll's deputy; Paul McGinnis, deputy commissioner of the State Bureau of Prisons; and Drs. Kipp and McCracken.

The official party reached the death house by prison van from the administration building at 8:01 p.m.

At 8:02, a guard opened a door on the right side and at the far end of the prison chamber. Rabbi Koslowe, dressed in the formal robes of a spiritual leader of his faith, walked through the door. He was reading the Twenty-Third Psalm.

"The Lord is my shepherd; I shall not want.

"He maketh me to lie down in green pastures: He leadeth me in the paths of righteousness for His name's sake.

"Yes, though I walk through the valley of the shadow of death," the rabbi intoned as he walked slowly down Rosenberg's "last mile."

Behind the rabbi came Rosenberg, staring straight ahead. He was clean-shaven, he no longer had the mustache which he wore when he went to the death house. He wore a T-shirt, brown trousers with a tan pinstripe and loafers.

For a brief moment, a puzzled look appeared on his face when he took one quick glance at the four benches at the rear of the chamber where the official witnesses sat.

Otherwise, he gave no sign of emotion. While the guards strapped him in the chair, adjusted the straps and electrodes, he gazed calmly ahead. Once, the trace of a sardonic smile creased his lips.

Warden Denno signaled Francel that all was ready and the slim little executioner threw the switch. There was buzzing for three seconds, and Rosenberg lurched forward, his hands clenched.

Francel released the switch. The body of Rosenberg, half dead, relaxed. Then came the second charge—for 57 seconds. Again the man tensed and again relaxed as the buzzing halted. Then came the third charge.

The doctors stepped forward and applied their stethoscopes, "I pronounce this man dead," Dr. Kipp advised the warden. Quickly two guards bundled the lifeless body onto a hospital cart and wheeled it into the autopsy room.

Warden Denno stepped from his position along the wall to the right of the chair and advised the three newspapermen of the time of death.

Almost immediately after he resumed his position—at 8:08 p.m.—the door to the left of the chair opened and down the "last mile" came Ethel Rosenberg—calm, unsmiling, her thin lips drawn to a narrow slit.

Rabbi Koslowe preceded her, reading aloud passages from the Fifteenth and Thirty-First Psalms. On her left was Mrs. Evans. Mrs. Many, who said she "filled in" from her regular job as telephone operator, was on her right. Two male guards followed.

Mrs. Rosenberg had reached the chair—had one hand on it—when suddenly she turned and grasped the hand of Mrs. Helen Evans, a prison matron who had been in constant attendance of Mrs. Rosenberg during her two years in the death house. Then she put her arm around the elderly woman and kissed her left cheek. She mumbled a few words, turned and sat down in the chair.

The condemned woman was dressed in an ill-fitting green figured print dress supplied by the state. She wore no stockings and on her feet were loafers similar to those worn by her husband. She did not know as she sat there that her husband already was dead. Similarly, Julius, when he was strapped into the chair, did not know whether his wife had preceded him in death.

When the first electric shock was applied, a thick white stream of smoke curled upward from the football-type helmet on her head.

The juice went off, and the burned body relaxed. Then came the second shock…the third…the fourth. A prison guard stepped forward, released one strap and pulled down the round-necked dress. Drs. Kipp and McCracken applied their stethoscopes, then conferred in low tones. Executioner Francel joined them.

"Want another?" he asked.

The doctors nodded and stepped back to their positions beside Denno, alongside the wall.

Francel again applied the switch.

When the doctors examined the body for the second time, they quickly pronounced her dead.

The Rosenbergs and others were doomed when Igor Gouzenko, a Russian cipher clerk in the Soviet Embassy in Ottawa broke with Communists and fled one night in 1945 with his shirt crammed with spy documents.

Gouzenko now is living under an assumed name, and police protection, "somewhere in Canada." The information he gave put police on an international espionage trail."

In December 2016, Mark Denbeaux, a professor at Seton Hall University, published a research paper that suggests that Ethel Rosenberg was innocent and unjustly tried and executed. The abstract of the paper reads:

Regardless of whether Ethel Rosenberg was guilty of the offense for which she was tried, convicted, and executed, there is little evidence upon which that conviction was based. Even the United States Government believed so. Their prosecution of Ethel relied solely on the testimony of David and Ruth Greenglass. An internal FBI memo dated on July 17, 1950, declared there was not enough evidence to arrest Ethel Rosenberg and the FBI did not discover any new evidence against her between the release of that memo and her arrest on August 11, 1950. Additionally, no further proof was found between the time of her arrest and her indictment on January 31, 1951. Ironically, it was during that brief period that the testimony of Greenglass and his wife dramatically changed as to the extent of Ethel's supposed involvement in the alleged conspiracy.

Her conviction and execution rested on three claims: (1) Ethel asked Ruth to convey Julius' espionage recruitment offer to David; (2) Ethel typed up notes containing nuclear secrets in order to transmit them to the Soviets; and (3) Ethel and Julius received a mahogany table and other gifts from the Soviets as a reward for their commitment to the cause. Of the three, the only evidence present at the time Ethel was indicted was Ruth's statement that Ethel asked Ruth to convey Julius' recruitment offer to David. Despite giving several statements, over the course of eight months, neither Ruth nor David Greenglass mentioned Ethel typing up the notes until two weeks before trial. The indictment and pretrial documents also fail to report that

Ethel received gifts from the Russians. This accusation was first introduced into the trial documents during the Greenglasses' trial testimony.

The conclusion in the July 17, 1950, FBI memo, stating that the evidence against Ethel was insufficient to warrant prosecution, was ignored throughout her arrest, prosecution, conviction, and execution.

The reason for her trial seems clear: Ethel was executed because she refused to cooperate with the Government to help convict her husband, Julius. Ethel was merely a pawn used for leverage in the government's attempt to build a case against Julius Rosenberg.

BIBLIOGRAPHY

Books and Journals

Anderson, George. *History of New Mexico: Its Resources and People*. Vol. 2. New Mexico: Pacific States Publishing Company, 1907.

Birchell, Donna Blake. *Wicked Women of New Mexico*. Charleston, SC: The History Press, 2014.

Bryan, Howard. *Albuquerque Remembered*. Albuquerque: University of New Mexico Press, 2006.

Chavez, Fray Angelico. *But Time and Chance: The Story of Padre Martínez of Taos*. Santa Fe, NM: Sunstone Press, 1981.

Cowboy Chronicle 26, no. 10. "Marino Leyba Was the Sandia Mountain Desperado" (October 2013).

Johnson, Byron A., and Sharon P. Johnson. *Gilded Palaces of Shame: Albuquerque's Redlight Districts 1880–1914*. N.p.: Gilded Age Press, n.d.

Keleher, William Aloysius. *Turmoil in New Mexico, 1846–1868*. Santa Fe, NM: Sunstone Press, 2008.

MacKell, Jan. *Red Light Women of the Rocky Mountains*. Albuquerque: University of New Mexico Press, 2009.

Marriott, Barbara. *Outlaw Tales of New Mexico: True Stories of the Land Of Enchantment's Most Infamous Crooks, Culprits, and Cutthroats*. N.p.: TwoDot, 2012.

Metz, Leon Claire. *The Encyclopedia of Lawmen, Outlaws, and Gunfighters*. New York: Facts on File, 2003.

Mitchell, Pablo. *Coyote Nation: Sexuality, Race, and Conquest in Modernizing New Mexico, 1880–1920.* Chicago: University of Chicago Press, 2005.

Thompson, Jerry D. *A Civil War History of the New Mexico Volunteers and Militia.* Albuquerque: University of New Mexico Press, 2015.

The War of the Rebellion: A Compilation of the Official Records of the Union and Confederate Armies. Vol. 9. Washington, D.C.: Government Printing Office, 1880–1901.

Internet

Albuquerque Historical Society. "Civil War in Albuquerque." http://www.albuqhistsoc.org/SecondSite/pk207civilwarinabq.htm.

———. "Factoid E Answer." http://www.albuqhistsoc.org/factoids/eAnswfactoid.htm.

Blonger Bros. "The Blonger Brothers Ride." http://www.blongerbros.com/news/Sam_Marshals.asp.

———. "Lou Blonger Assaults Park Van Tassel." http://www.blongerbros.com/news/Lou_VanTassel.asp.

CBS News. "The Brothers Rosenberg." http://www.cbsnews.com/news/60-minutes-brothers-rosenberg-cold-war-spying.

Digital History. "ID 586—UH." http://www.digitalhistory.uh.edu/disp_textbook.cfm?smtID=3&psid=586.

Genealogy Trails. "The Confederate Invasion of New Mexico, 1861–62." http://genealogytrails.com/newmex/civilwar.html.

Genealogy Village. "Family History 19." http://nmahgp.genealogyvillage.com/AllFamilyHistory/fa19.htm.

Historum—History Forums. "Civil War: Glorieta Pass." http://historum.com/american-history/43549-civil-war-glorieta-pass-3.html.

Johnson, Byron A. "The Rousing Life of Elfego Baca." New Mexico Office of the State Historian. http://dev.newmexicohistory.org/filedetails_docs.php?fileID=22142.

Know Southern History. "Buried Confederate Cannons." http://www.knowsouthernhistory.net/Articles/History/WSI/confederate_cannons.html.

Library of Congress. "Interview with Mrs. William C. Heacock." https://www.loc.gov/item/wpalh001300.

National Public Radio. "Ethel Rosenberg Was Collateral Damage in Soviet Spy Case, Sons Say." http://www.npr.org/2016/12/23/506686944/ethel-rosenberg-was-collateral-damage-in-soviet-spy-case-sons-say.

Bibliography

New Mexico Compilation Commission. "L.E. MCRAE and T.G. GREGORY, Appellants, vs. DOMINICK CASSAN, Appellee." http://www.nmcompcomm.us/nmcases/NMSC/1910/1910-NMSC-038.pdf.

New Mexico Office of the State Historian. "Baca, Elfego." http://dev.newmexicohistory.org/filedetails_docs.php?fileID=22142.

Oregon State Library. "A Bill to Be Submitted to the Legal Electors of the State of Oregon for Their Approval or Rejection at the Regular General Election to Be Held on the Sixth Day of June 1904…." http://library.state.or.us/repository/2010/201003011350161/1904-324-2-Or3b.pdf.

The Outlaws that Got Away. "The Wild Bunch." http://theoutlawsthatgotaway.blogspot.com.

Panjury. "William Hayes Pope." https://www.panjury.com/trials/William-Hayes-Pope.

Rosenberg Fund for Children. "Rosenberg Case Overview." http://www.rfc.org/caseoverview.

Santa Fe Trail Research. "Fort Union NM." http://www.santafetrailresearch.com/fort-union-nm/fu-oliva-5b.html.

SSRN. "The Government's Hostage: The Conviction and Execution of Ethel Rosenberg." https://papers.ssrn.com/sol3/papers.cfm?abstract_id=2885448.

Tales from the Morgue. "1986: H-Bombing New Mexico." http://elpasotimes.typepad.com/morgue/2013/07/1986-h-bombing-new-mexico.html.

UNESP Institutional Repository. "Cartographies of Women in Prostitution: Territories, Heterotopies and Its Interfaces with Psychology." http://repositorio.unesp.br/handle/11449/141497.

UPI Archives. "Rosenbergs Go Silently to Electric Chair." http://www.upi.com/Archives/1953/06/20/Rosenbergs-go-silently-to-electric-chair.

U.S. House of Representatives. "Gallegos, José Manuel." http://history.house.gov/People/Detail/13591?ret=True.

Wikipedia. "Julius and Ethel Rosenberg." https://en.wikipedia.org/wiki/Julius_and_Ethel_Rosenberg.

———. "Milton J. Yarberry." https://en.wikipedia.org/wiki/Milton_J._Yarberry.

WikiVisually. "Milton J. Yarberry." http://wikivisually.com/wiki/Milton_J._Yarberry.

Bibliography

Newspapers

Albuquerque Citizen. "Police Raid, Opium Den." October 23, 1905.
Albuquerque Evening Review. "The Balloon Ascension, Horse Races, Base Ball, Etc., Etc." July 6, 1882.
———. "In a Bagnio: Lou Blonger Assaults Park Van Tassel and Will Roast on the Legal Gridiron." September 12, 1882.
Albuquerque Journal. Advertisement, July 2, 1882.
———. "The Aeronaut's Balloon Bursts before It Is Inflated." August 16, 1882.
———. "Elam Gets 15 Years in Treasure Scheme." May 30, 1987.
———. "Horn to Deliver Valverde Speech." February 10, 1962.
———. "Powerful H-Bomb 'Nearly Destroys' City; 25,200 Die." July 13, 1957.
Albuquerque Morning Journal. November 23 and 27, 1886.
———. "Pipes and Patient Medicine." September 13, 1983
Albuquerque Tribune. "Albuquerque Had a Wild West Gun Battle 75 Years Ago." November 20, 1961
El Paso Herald. "Court Against Baca Dismissed." December 17, 1915.
Farmington Daily Times. "Suspect Sold Army Bogus Items." March 23, 1986.
Santa Fe New Mexican. "H-bombing NM, Crewmembers Recall Humor Trailed in Wake of Bomb Accident." August 29, 1986.
———. "A Quarter of a Century Ago." March 30, 1912.
———. "Santa Fean Unwilling Witness to Triple Lynching." March 15, 2003.
Santa Fe Reporter. "The Disappearance of Colonel Potter." July 13, 1994.
Santa Fe Weekly Gazette. "Padre Gallegos: Democracy and Our Position." September 10, 1853. https://www.abqjournal.com/583221/the-case-of-the-fourlegged-bootlegger.html.
Socorro Chieftain. "Buried Confederate Cannons." August 7, 2004.

ABOUT THE AUTHOR

Cody Polston is the author of four books on paranormal topics, the host and producer of the popular podcast *Ecto Radio* and the writer for GHOSTHUNTER X magazine. He is the founder of the Southwest Ghost Hunters Association and has been investigating paranormal claims since 1985. He is also an amateur historian and enjoys giving tours of Albuquerque and other historic sites in New Mexico. Cody has appeared on numerous radio and television programs, including *Dead Famous* (Biography Channel), *Weird Travels* (Travel Channel) and *In Her Mother's Footsteps* (Lifetime Channel excusive), as well as *Extreme Paranormal* and *The Ghost Prophecies* (both A&E network).

Visit us at
www.historypress.net

This title is also available as an e-book